MARCOS MATEU-MESTRE

FRAMED INK

**DRAWING AND COMPOSITION
FOR VISUAL STORYTELLERS**

designstudio PRESS

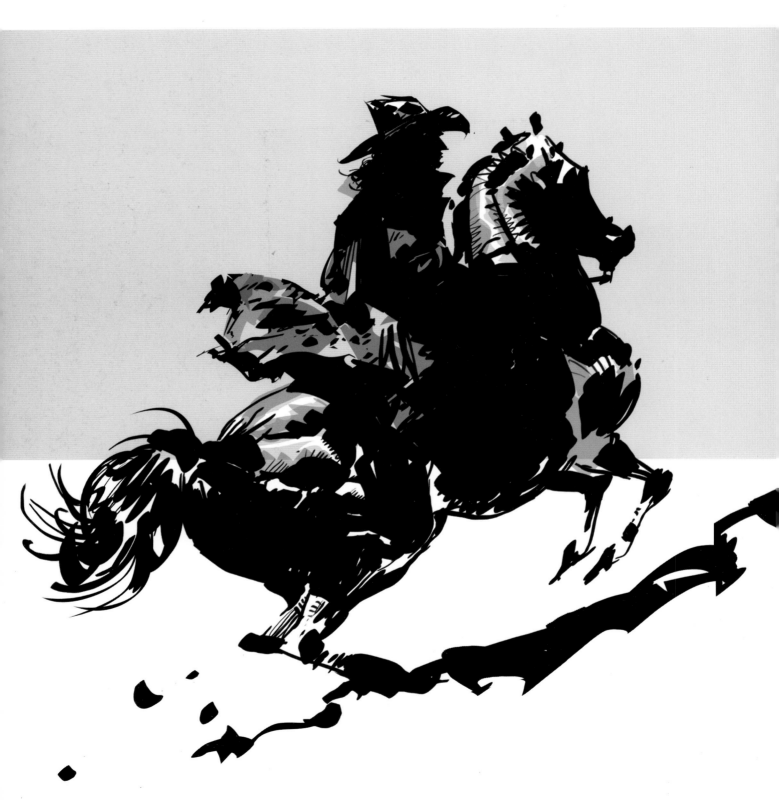

To Alfie

Thanks to my family: Joan, Margalida, and Carme. Special thanks to Jeffrey Katzenberg, Bill Damaschke, Paul Lasaine, Shannon Tindle, Adolfo Martínez, Marcelo Vignali, Armand Serrano. My gratitude as well to everyone who supported the making of this book and to all the colleagues who create generous art and beauty for all to enjoy, and from whom I get daily inspiration.

Framed Ink: Drawing and Composition for Visual Storytellers

Copyright © 2010 by Design Studio Press

Website: www.designstudiopress.com
E-mail: info@designstudiopress.com
Printed in Korea
Third printing, first edition, July 2010

10 9 8 7 6 5 4 3

ISBN: 978-193349295-7
Library of Congress Control Number: 2010923308

Copy Editor: Teena Apeles
Book Design: Marcos Mateu-Mestre

Published by
Design Studio Press
8577 Higuera Street
Culver City, CA 90232

TABLE OF CONTENTS

FOREWORD

I have often said that Animation is the purest form of creativity. Every step of a production, from the storyboards to the music to the final cut, springs from an artist's imagination and is realized by his or her talents.

Of course, we all have to start somewhere. I believe that filmmakers must first understand the complex visual grammar of the medium before they can explore their personal styles and channel that creativity. You have to know the rules before you can break them.

With *Framed Ink*, Marcos Mateu distills his twenty-plus year career in feature animation into a clear, practical manual on the language of images. Marcos has a special eye for composition, lighting, and continuity that creates a tangible sense of mood and drama in all of his work.

By reading this book, you are entering into a "Master's course" of visual storytelling, and I think you couldn't ask for a better teacher.

So start learning, start drawing, and start down your own path to creativity. I can't wait to see what you come up with…

Jeffrey Katzenberg
CEO, DreamWorks Animation

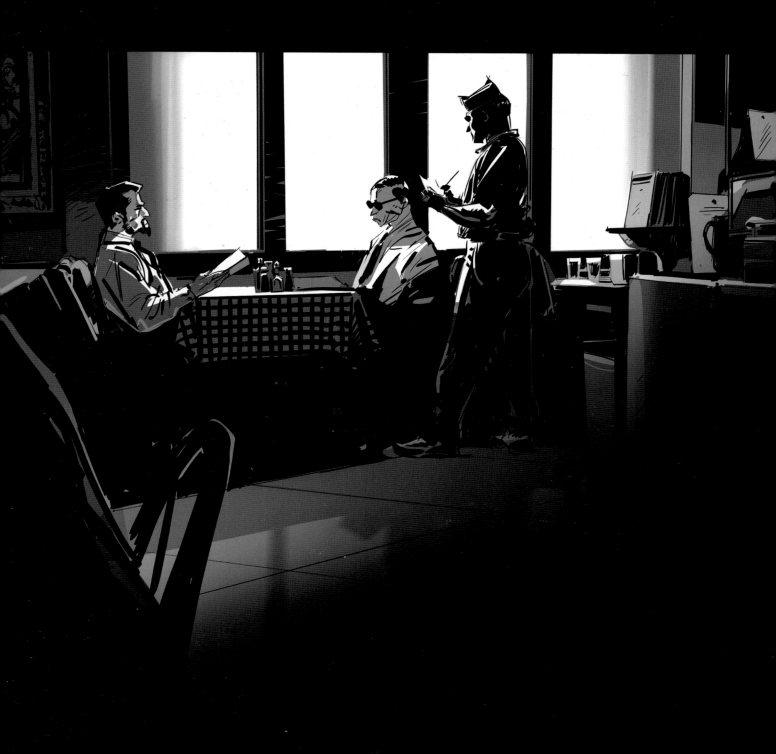

INTRODUCTION

Narrowing Down

The first thing a reader sees of a book is its **cover**, which sums up at a glance what the book is about; the broadest, most general statement.

Then, **the table of contents** quickly tells the reader the subject matter the author will discuss in the book.

And finally **the explanations**, the details, the nuances, and the subtleties will give the reader a complete understanding of what the message of the writer is.

It is important to know as artists what we want and need to say, and how to prioritize and order the elements we will use, because they are what will help us get our message across. These factors inform our approach to drawing in general and for storytelling purposes.

So, first we need to be clear about the **general level of intensity** the image should convey given its purpose within the story as a whole. What type and level of emotion are driving the moment? Extreme happiness? Subdued sadness? Is it about explosive action?

Next there is the narrative detail, explaining what the **specific action** is about, the reason, and the anecdote within the mood. Do we feel sad because we are missing somebody? Or because we lost a winning lottery ticket?

Finally, the **artistic execution and style** glue everything together while supporting the story.

By following these steps we aim to deliver clear messages with our artwork, frame by frame, and in continuity with the story as a whole.

Marcos Mateu

sly we will a

are we achiev

mood do we

c sequence c

are we going

in our drawin

can we leave

CHAPTER 1

General Thoughts on Narrative Art

Think, feel. What is the whole story, the specific sequence, the shot about?

Let's not forget that when we are talking about visual storytelling, the image is the vehicle and not the end in itself. We cannot afford to get the audience stuck on a particular frame just because the drawing or the scene looks great without a specific purpose for it within the story.

Obviously we aim to produce the best quality art, but we should prioritize the following:

- What are we trying to say in our narration as a whole?
- What mood do we want our audience to be in throughout the story and at any given time within a specific sequence or shot?
- What is the function of this moment within the story?
- How are we going to take our audience there?
- What in our drawing is contributing to the general statement?
- What can we leave out without changing what we are trying to say?

Basically, when we are drawing for a storyboard or a graphic novel, we are first of all doing an exercise in storytelling, as opposed to creating pieces of art for a show. If the drawing doesn't serve a purpose within the bigger picture, it will just pull the audience out of the narration, making them conscious of the fact that they are simply setting their eyes on a paper with brushwork on it rather than living an experience, as following a story and its characters should be.

How do we bring an audience into our world?

Translating "reality" into "our reality": Capture a mood and deliver it to your audience

The reality around us is always triggering moods and feelings in our brain, generating a more or less powerful emotional response from us, whether it's a beautiful and evocative landscape or a rather menacing one; the expression on a stranger's face; someone's funny, aggressive, rude, or intriguing attitude on the street; an interesting building; or the way the sunlight is hitting on a patch of trees in a park. There is always a vibration or expression emanating from our environment—positive or negative, relaxing or threatening—that affects our mood and the way we feel in one way or another.

As artists we need to be especially perceptive of this surrounding energy, *because it is our work to translate it into something physical, more tangible*, like a drawing or the narration of a story that will successfully convey and deliver all of it effectively to an audience.

In this book we will talk about "artistic grammar" and techniques that will help in this translation process, but, besides technique, we will always need our individual perception, instinct, passion, and intuitive understanding of things in order for this "translation work" *not to come out as completely mechanical, predictable, and formulaic*. Technique is one thing; feeling and mood—the expression of which is our goal—are another. The former will help us put the latter out there, but will never take its place.

If we are going to tell a story, we need to believe in it and its characters. If we are going to move an audience, we need to be moved ourselves first. We just won't be able to give something that we don't have.

The general tone of the story / Consistency

Consistency in our vision from the first to the last frame is essential the moment we decide to grab pen and paper. It is important as we try to create fiction, a fantasy with shapes, light, and rhythm. Our world and characters are made of paper and yet we have to make the audience experience them as real.

Making every element coherent with the rest (emotional ups and downs included) as part of the solid chain that is the world we are creating, will give credibility to our work. That's why our choice of first shots will establish our sense of drama, comedy, or action for the whole narration (see also page 038), and the tone and visual style we will commit to. Doing something "out of character" after that would pull the audience out of the reality we are trying to build—and then the magic would be gone.

Once we visualize in our minds a general tone for the narration (comedic, snappy, epic, dramatic, intimate, and so forth) and how to ramp up to its climax (pages 059, 075), we can start developing images that always serve the concepts we have previously established.

Not telling the audience things, but rather making them feel things.

One of our main tools when creating a world of "parallel reality" is *atmosphere*, which is based on lighting, pacing, and color.

Sometimes it comes down to using insinuation to drive action, *foreshadowing things rather than telegraphing them*, on both artistic and narrative levels. This will allow our audience to participate more in the adventure. The idea behind this is that, no matter how hard we try, we will never represent "reality as it is," simply because we each have our own unique version of reality in our minds.

Obvious evidence of this is a plein-air painting trip with a number of equally talented artists. Even if they all paint the same tree or the same boat, the truth is, at the end of the day, they will all go back home with different interpretations of the subject, actually very different paintings. Starting with the cropping of the scene, the way each artist emphasizes one thing versus another, even the actual color palette will be different; one will favor warm tones against the cooler tones of the other, even when they are all convinced they depicted things "exactly" as they were, therefore transmitting to their audiences a completely different emotional message in each case.

So, as much as possible, we will be better off giving the audience the opportunity to create their own reality in their minds. Let them own the visuals and therefore the story, up to a degree. Let's give them the elements they need so that they can subconsciously feel the urge to fill in the gaps with what is only insinuated to them.

Let's tend to use simplicity, shadows, and silences as opposed to an avalanche of detail, so that they can experience them in their own way. Let's always leave them wondering about a little something, longing to know a bit more, to continue watching or reading, and let's give them answers while simultaneously raising new questions. It really is a seductive game.

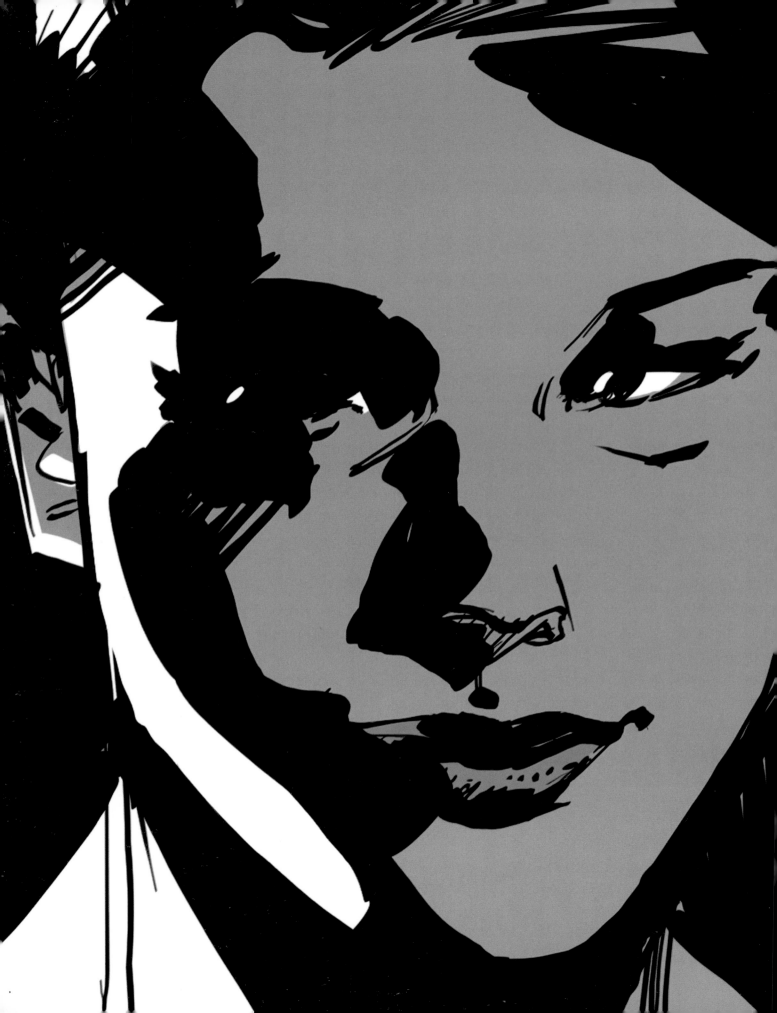

CHAPTER 2

DRAWING AND COMPOSING A SINGLE IMAGE (BASICS)

Atmosphere

A sense of reality

We want to transmit the emotion of the landscape—the face—the piece of architecture in front of us onto the paper. And it's very tempting to try to do so by just copying or transferring every shape and detail of it with our brushes as a photograph would, assuming such a literal transfer would be the best way to get as close as possible to the feeling and sense of atmosphere our eyes and mind get from the reality in front of us.

But at the end of the day the mountain and the tree stay in the countryside. *All we can transfer onto the paper is just an illusion*, one of the elements in front of us. Then what is more faithful to reality, the literal image of something or its spirit?

Personally, I'm going with the spirit.

If we try to draw somebody's portrait from a picture and we use, for example, the "square grid pattern" technique, we will surely end up with a perfect transfer of every detail and feature of it on the paper, but then we are not making any choices (see page 024). In this case, *all of the features will end up looking equally important*. Is this really how we see or perceive that person? *Is it really how he or she is?*

Sure, some lines or areas should be more representative or important within his features and therefore should stand out more.

How about we sit in front of our model, squint our eyes, see what stands out then, and what the first quick read of the face and the expression is? If we follow this, the result would be a more accurate *representation* of that person.

So a "photographic" depiction is not necessarily the answer. *Expression* is. Energy transmitted is. Mood is. These are the things that will ultimately transmit the character's real personality to the audience.

The same will happen with any other type of subject.

Lighting

Is what is in front of us and what we perceive actually the same thing?

The same piece of reality we try to portray will change completely under different environmental conditions. *How* we see what's in front of us is even more important than the object itself. **The same thing can tell us *many* different stories.** Our choice of point of view, lighting, and so forth, at every moment, needs to be intimately related to what we try to say or express.

Let's imagine that we are going to shoot two movies, and our budget is so limited that we can only have one location, say a room with a table, four chairs, and two windows to the outside. The first movie we have to shoot is a cute tale for little kids and, the second, the most upsetting horror movie ever made. And we can't even reposition a single chair in order to create a more appropriate environment for each film. Is the audience going to buy into it?

If we need to create two completely different worlds, two different perceptions of the world, two completely different *experiences*, how will we do it?

Lighting is the first answer. By changing the lighting we change the reality in front of us, or, to be more precise, we radically change our perception of it. Making things lighter or darker, showing more or less, being more obvious or more ambiguous will result in different worlds.

Back in our "set location room," if we switch all lights on and leave all the windows open then we will see everything, every little detail of it. Not much will be left to our imagination and therefore we will feel more confident and relaxed. If we shut all the windows and switch off all the lights, we will be in darkness and none of the furniture or objects will exist, *not from a visual point of view.*

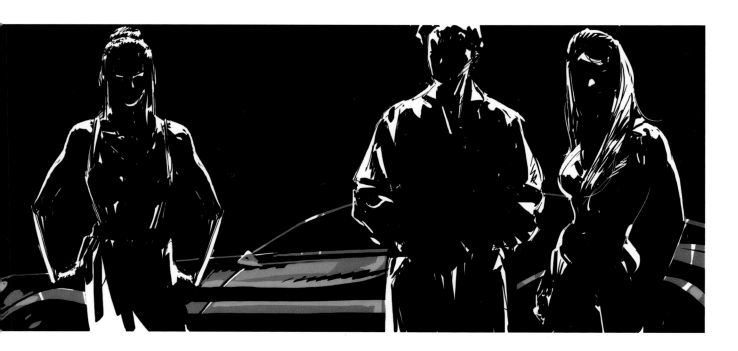

Drawing in chiaroscuro (...or the line that never existed anyway)

The lines we draw in an average illustration do not exist in reality, they are only a means for us to define on paper the space that the objects depicted by such lines occupy. But since the perception of such objects might change dramatically depending mainly on lighting choices, are these lines that important after all? Obviously we will need a good knowledge of traditional line drawing before we get into further concepts like the ones we are talking about now. Training in this discipline will allow us to place every item (objects as well as masses of light and dark) where and how we want and need them on our drawing surface.

But past that we will say since *contour lines do not exist in reality*, in some cases *they just might get in our way when drawing what we really need to draw*. And while talking about perception, I would suggest to forget for a moment everything we have visually assumed in our everyday lives, since these might make us go mainly by clichés.

Life is obviously easier if we "identify," assume, and label things quickly. In fact we have historically needed to live by these rules in order to quickly react to them as well in order to survive (despite the obvious possibility of making grand mistakes in the process). But since no dinosaur is chasing us right now (we hope), we can afford to think more quietly about what is in front of us and how we really perceive it, *without filtering it through any* **preconceived** *notions*.

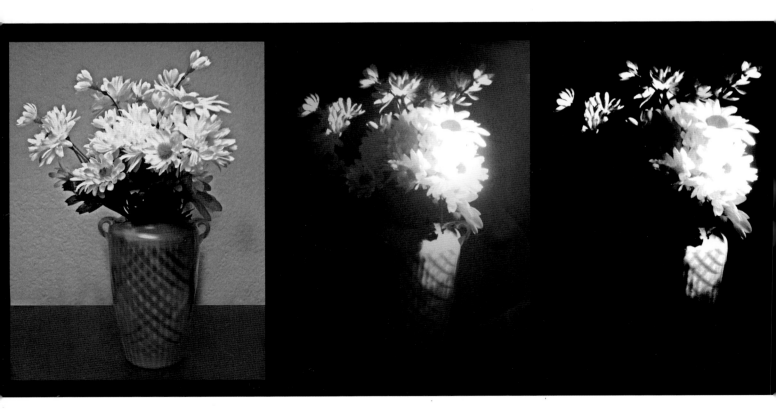

Studying reality as it appears in front of us

To put it another way, *how would we perceive the things we see* around us if we had just arrived to Earth from another completely different planet and we didn't know what "a person" looked like, what an ocean is, or what makes a tree different from another one? How would then our brains process what our eyes would see?

We would just have to go by impression, without being able to rationalize any of the elements around. And the impression we would have would depend, as we will see, not only on the physical elements themselves, but also on the conditions of the moment.

As an example, let's say right now a man is trying to paint a bunch of daisies in a flowerpot. Only some of them are lit, the rest are in the dark. He knows the precise number of flowers that are in the pot and, in an effort to represent reality "as it is," he is not going to stop trying to represent each and every one of the daisies on his painting, the flowerpot in all its detail, as well as all the objects around. But by doing so he is not going to find his way to "depicting reality" as he expects, since only part of the flowers and objects in the scene do "visually exist" under these specific lighting circumstances.

As we see, we need to look at what is around us, try squinting our eyes, skipping the *visually nonexistent details*, the unimportant, the unnecessary, and whatever is not contributing to the visual impression of what we see. *Let's get to the point.*

Let's go now to another simple example, a human head. We all know what it looks like, and what features and sense of volume it appears to have...

...but the question is, what happens the moment we start changing the circumstances around it? How many different stories will the same head be able to tell us?

The variety is great—some will tell a more relaxed, upfront story, while some might go to the realm of nightmares and then, worlds in between.

One of the main steps will be again to decide how much we want to show of the subject, how clear or how confusing the image will be, how close to an everyday, average impression of a human face do we attempt, or how far away from it do we decide to travel in order to create, in this case, an unsettling mood for our audience.

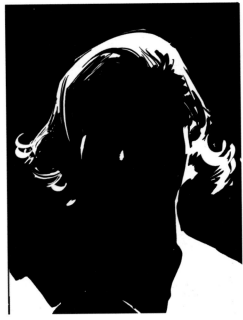
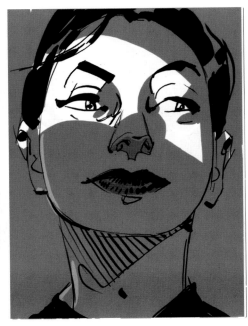
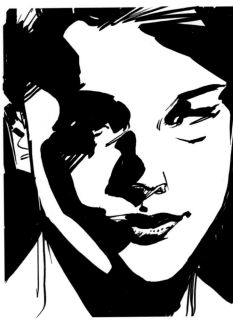

Obviously we need to apply all these concepts to a working surface; sometimes it is paper or a computer screen. Whichever we choose, the compositional challenges and its solutions will be the same, although the speed at which we can work will dramatically increase the moment we use digital technology given its great capacity to let us correct and edit faster than any other tool.

We have to compose images that will deliver the message the moment requires in an effective and easy to understand way. Whether the intensity of the scene needs to be low or high, to reveal more or less, to point out one element or another (decisions we will have to make at pre-planning stage), there are a number of compositional rules and elements that are available to us in order to achieve such effects as we will see from this point on.

How we see things usually, and how we don't

We all have a sense of what feels natural and familiar to us in terms of *what* we are used to seeing regularly, and *how* we are used to seeing it. The moment we start deviating from it we start creating images that feel unusual to us, which can mean slightly special and interesting, very special and interesting, or just weird and possibly unpleasant. We have to decide what we need at each moment.

For example, at how high or how low do we want to position the camera? Do we want it at our eye level? Higher looking down? Lower looking up? Much, much lower to increase the level of drama even more (pages 040–041)? What kind of lens do we want to use (pages 028–030)? Do we want a regular feel to the shot or do we want to force the sense of perspective? And, if so, do we want to force it by exaggerating the perspective or by flattening it?

Selective vision

Normally we go about life focusing on what is relevant to us at every given moment. If we are walking down the street, we basically pay more attention to traffic in order to remain safe, or to the shops in the street to make sure we don't miss out on the one we are looking for. Or if we are at a bar waiting for a friend, we look at people's faces having our friend's features in mind so that we can make the match and recognize him the second he walks in. If we are relaxing on a Sunday afternoon, we might direct our focus toward the landscape around: the beautiful palm trees, or maybe other people strolling around, or kids having a good time to feel that we are part of it and "share the moment."

The point is, even if our eyes are seeing many things at once, we do prioritize them based on our need at the moment, making specific things stand out above the rest.

A good example of this is when we walk with somebody. We quickly glance at our watch and then we go back to our conversation. Our friend then asks us what time it is and we have to look at the watch again, because the first time we did so we were not really interested in what time it was but whether we were late or not to our next appointment. That's the information we needed and that's the information we got out of it. No more.

So we look at things depending on what we require at the moment, and this is how *we will select and highlight certain elements in our compositions* as part of the visual message we want to deliver.

Let's frame and illuminate things in order to show *what* we need to show, *how* we need to show it, and, as much as we can, *let's crop out the rest.*

Putting the chosen elements on paper / Basic checklist

We certainly have a vast number of visual tools and devices to help us put all these on paper. In the next pages are some of the basics to get us started and make things work on a screen or panel. (Notice these rules are sometimes meant to be broken! We will always try to find a creative and innovative way to do and say things, as long as it makes sense). Later on in the Composing Shots with a Purpose section of the book, we will see practical examples that demonstrate how these and many more can be combined to achieve the needed results.

Long or wide shot: This type of shot helps establish a general sense for the scene. It allows us to show the character within his or her context or surrounding circumstances. (Where are we? Where is the action taking place? What types of elements will we have to interact with?)

Medium shot: This still offers a wide view, but elements that otherwise would interfere with the message of the shot are cropped out.

Close-up: This provides a better feel for the features and the reaction of a character to a situation. At this point, the reaction will be more important to an audience than whatever caused it.

Extreme close-up: Here the audience will become one with the person on screen. This is not the only way to achieve this effect, as we will always have other options such as the use of a point of view camera shot (page 053).

Rule of thirds: Drawing a perfectly *symmetrical* composition will do the job for an epic or otherwise special moment, but when used regularly it will just feel too self conscious and convenient, missing any natural feel to it. Compositions are normally better based on off-center patterns, like when we compose by thirds, which allow us to achieve this off-center feel while at the same time preventing us from going too close to the sides of the frame, falling again into a strange and uncomfortable look.

Positioning our main elements on any of these axes or on their resulting intersections will help us get an interesting and well-balanced image.

Staying on the same side of "the line": A device that will help us keep a clear sense of geography along the same sequence (full explanation on page 089).

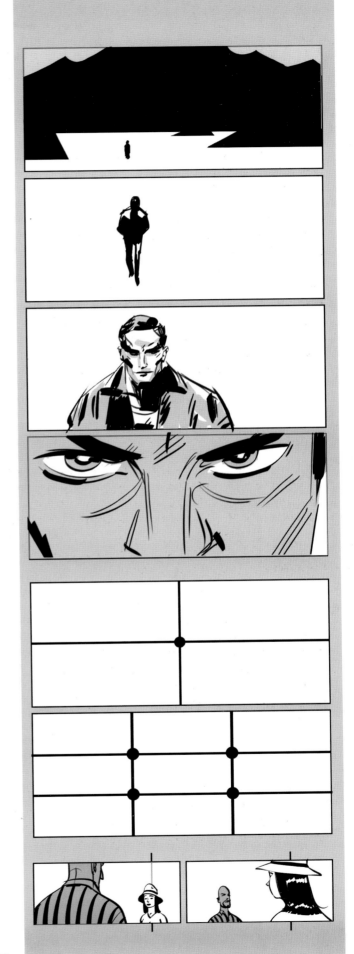

Lighting: Helps us focus the audience's attention on very specific and limited areas by creating contrast (page 075), for example, a bright, illuminated area surrounded by a frame of darkness, or by creating a point of major contrast and therefore visual tension where needed.

Lines: Whether we are talking about physical lines or linear motives created by a series of aligned elements in the scene, the emotional result will vary depending on the direction and arrangement of such lines.

Curved shapes will always appear to be more subtle and peaceful, *diagonals* being on the other end, more dynamic and aggressive. *Straight lines* will represent assertiveness while *curves* will be kinder and easier on the eye.

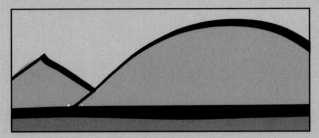

We can also use lines to direct the eye toward a specific element in the panel. Besides the perspective element we will mention shortly, "lines" can be anything from a tree branch, a powerful and elongated element of graffiti, a row of clouds pointing in a certain direction, or the imaginary one that links the heads of different characters.

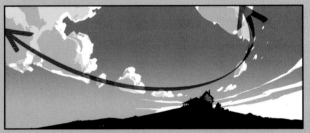

Avoid tangencies and weird coincidences: Such occurrences will take an audience away from the story moment by making them focus on "what looks weird" in a shot. Tangencies and coincidences happen when we don't really pay attention to how the elements in a shot are composed or combined, though they might look like they have been planned or premeditated, creating a disruptive effect that doesn't have any business in the story we are narrating.

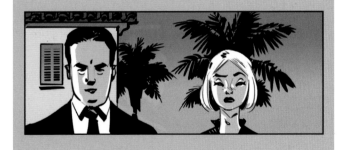

Cutting in: Sometimes the moment will require us to jump closer to a detail in the scene we are in to better appreciate the expression of a character's eyes or the subtlety of an object that will shortly become relevant in the development of the facts. In this case, always make sure that the subject stays in the same position in both frames proportionally within the measurements of the screen (page 055).

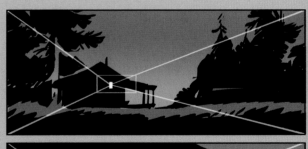

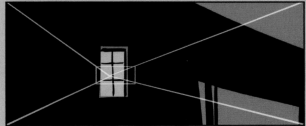

Size difference: Creating an uneven balance of shapes and masses in a frame (big, medium, small—see also page 049) automatically makes an image deeper, more dynamic, and interesting. Also, some characters or elements will need to be more prominent than others for story purposes, and possibly this "weight" relationship will change throughout its course. Whatever the case is, one of the ways to establish this order of relevance is through the size relationship between them on the screen. This can be achieved by either just having a character or element actually bigger than others, or by positioning him relative to the camera in a way that he will appear to be bigger than the rest.

Perspective: We have the tendency to look toward where the vanishing point is since, especially in the case of architectural environments, all lines parallel to the horizon and among themselves, will be pointing at it, creating an obvious center of interest.

The main character's look direction: Whatever direction a prominent character is looking will influence the general composition no matter where the other elements are. As long as they don't overpower the actor, the audience will have the tendency to look in the same direction, anticipating something important to the development of the story is happening in that area.

Screen direction: Culturally we are used to reading in a certain direction, this being left to right or right to left, influencing the way we "read" the screen. If the action is going in the direction we are familiar with, our perception will be that, at that point, things are positive and going well, while the opposite would translate into hard times and difficulty.

Besides that, the action during the scenes of the same sequence will in most cases travel in the same screen direction consistently from beginning to end, to establish momentum and for clarity, unless a dramatic turn in the action is required for a specific reason.

Reinforcing the action with the background: When the sense of perspective in the backdrop accompanies the general direction of the action developed in the scene, the effect will be automatically enhanced.

One last thing before we get into the analysis of specific compositions based on the elements we have seen before. Something that will dramatically influence the way in which we see things on the screen—even when the camera is positioned exactly on the same spot, pointing at the same subject, in the same direction—is the kind of lens you decide to use.

To simplify, we will mention the two extremes in a broad way, the *wide-angle lens* (**A**) and the *long lens* (**C**). Right between them, the *50-mm lens* (**B**), when using 35-mm film, would be the approximate equivalent to how a human eye normally sees things, without any sort of distortion.

Both wide and long lenses will give us distorted views of the objects in front of us in comparison with what we would normally see with our naked eye, each in a very different and distinctive way that will influence the effect and type of visual message we imprint on a particular bit of our narration.

The *wide-angle lens* literally includes a wider view, from left to right and top to bottom, of the subject it points at. The *long lens* focuses on a much narrower portion of it. Therefore, in order to get the same section of landscape in both cases, the distance between the lens and the landscape will have to vary a lot from one to the other.

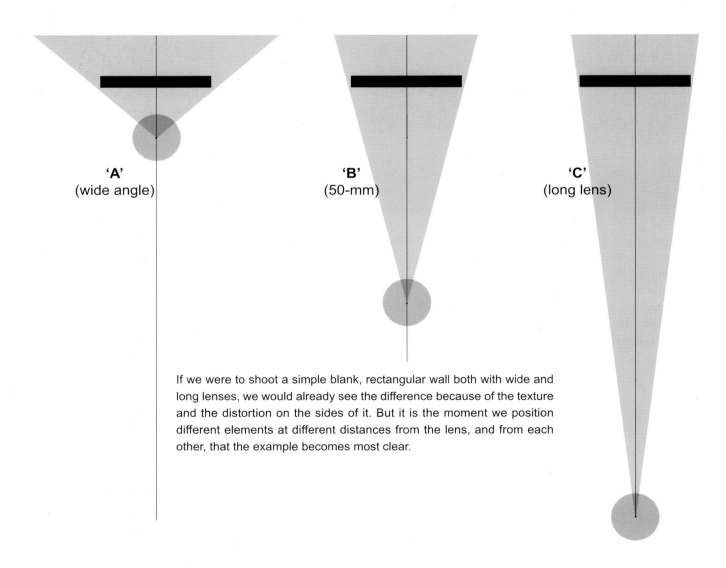

'A'
(wide angle)

'B'
(50-mm)

'C'
(long lens)

If we were to shoot a simple blank, rectangular wall both with wide and long lenses, we would already see the difference because of the texture and the distortion on the sides of it. But it is the moment we position different elements at different distances from the lens, and from each other, that the example becomes most clear.

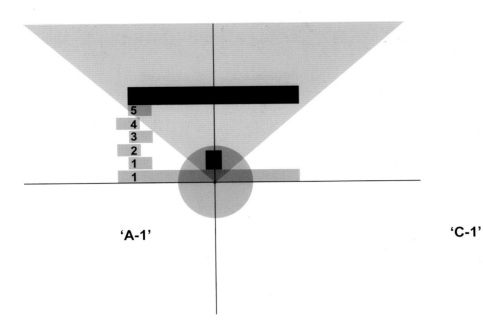

'A-1'

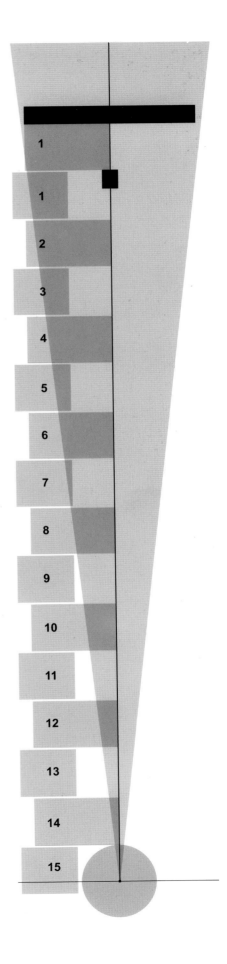

'C-1'

So let's imagine now we have a person (seen as a small black square in these diagrams) in front of a wall or building. We still have to position the camera closer or farther from this architectural structure (represented here by the thick, black line), depending on the kind of lens we use, in order to *get its whole facade in the shot*. The obvious difference now will be that in order to do so, in example **A-1** (wide angle lens), we end up being extremely close to the character, while in example **C-1** (long lens), we will be at a really great distance from him.

To put it another way, in **A-1**, the *distance between the lens and the character* is barely a fifth of the distance between the character and the building behind. In **C-1**, such distance is (*just as an example*) 15 times the distance between the character and the wall, resulting in the visual effect that, in this latter case, both elements appear to be much closer together because proportionally to the distance from the lens, they are.

And again, as a result of this, the farther back we move from the subject, while proportionally increasing the length of our lens to still crop the image by the sides of the building, we will see how the character and the building will appear closer and closer every time. So the bigger distance and the bigger focal length will mean that any depth clues that we could have in the scene tend to get minimized, flattening the image. Whereas when we use a wide-angle lens, all depth clues are enhanced to a point that (and going to the extreme) we might even end up playing with the proportional distances between the tip of the character's nose and his cheekbones, and then the one to his ears, resulting in a distortion of the features of that person's face, that would give us outrageously dynamic compositions on the screen.

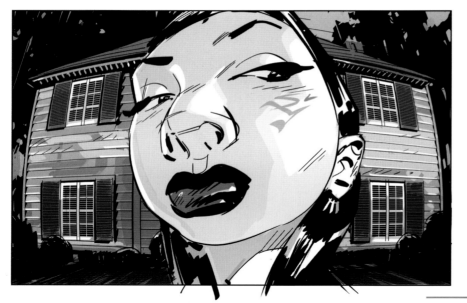

Here is how the same exact shot would look like in the three different cases:

A-1 wide-angle lens: The face here is absolutely prominent since the camera is extremely close to it. The distortion of its features and the one of the perspective in the background are very obvious since a small distance between two points perpendicular to the lens produces an exaggerated optical effect.

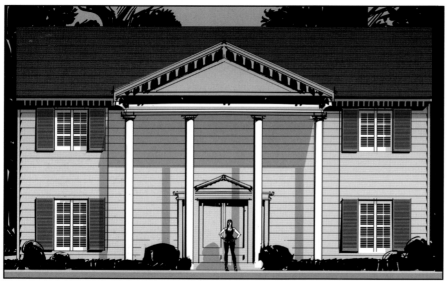

C-1 long lens: Next, if we try to get the scene with a long lens while (as in the previous example) still trying to include the whole width of the house in the frame, this would be the result. The character and the house would appear to be in a realistic proportion against each other since the distance between the two of them wouldn't be relevant at all compared to the distance between them both as a group on one end and the camera on the other.

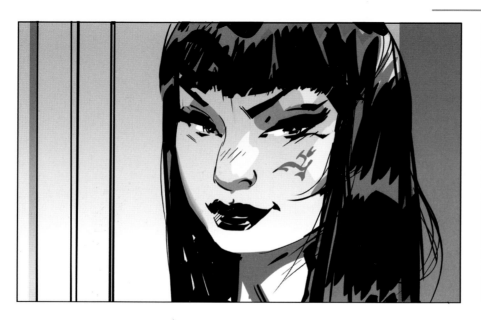

C-2 long lens: If the intention were to get the face within the frame as we did in the first shot, but from a big distance and with a long lens, then we would still keep the realistic proportion between the girl and background, therefore barely seeing a little portion of the house's door.

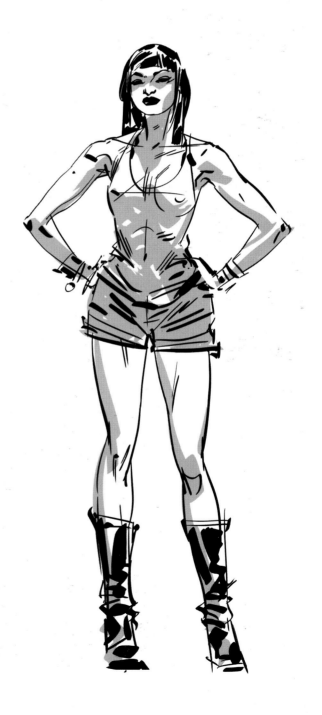

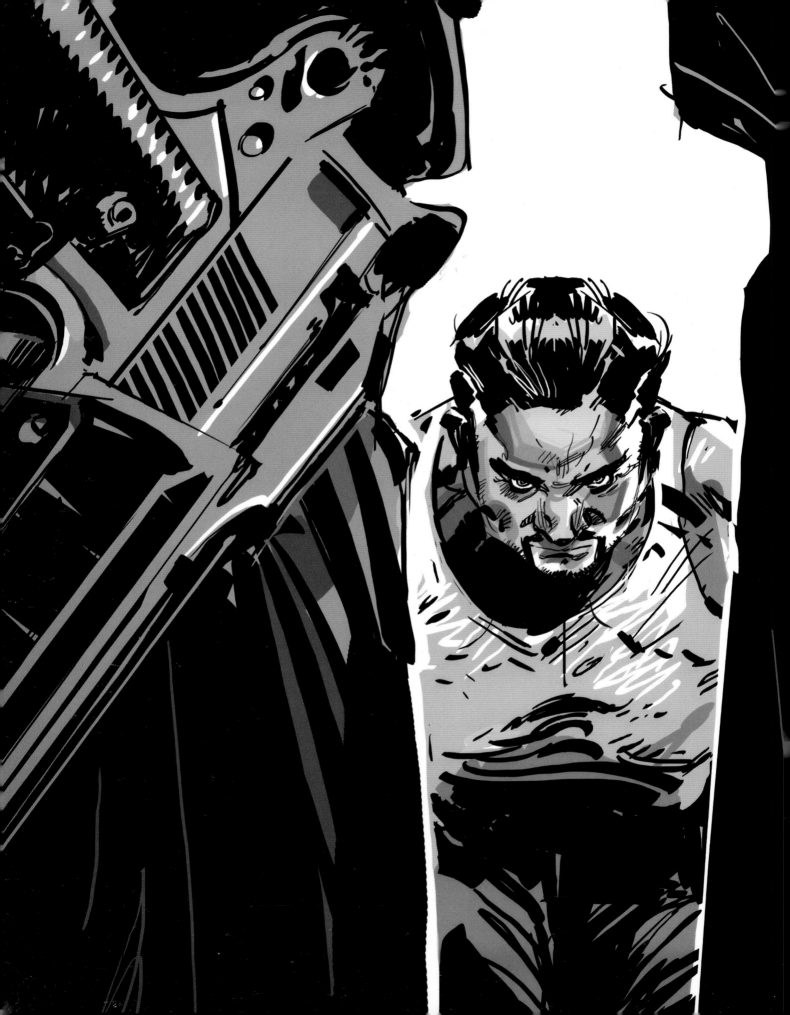

CHAPTER 3

COMPOSING SHOTS WITH A PURPOSE

Most examples in this section will include two little thumbnails: the first one shows the basic distribution of the light and dark masses in the shot, and the second shows the main lines of tension. With clear examples we will see how to achieve the creation of different emotions to serve the purpose of a specific moment within the narration. There are certain rules that will generally apply, and these can be applied to potentially any environment or situation.

Remember, in order to achieve the needed "quick read," do not think in terms of the "elements" you need to compose at first (characters, furniture, rocks, trees), but think in terms of basic, clear, and readable shapes (little thumbnails attached to each composition), and then compose your "elements" within.

Let's see a quick introductory example of this process.

Let's say we are trying to create an oppressive environment. We will try to create a composition that will 'visually strangle' our character, and for that we come up with a basic distribution of the light and dark masses as seen in example '**A**' below.

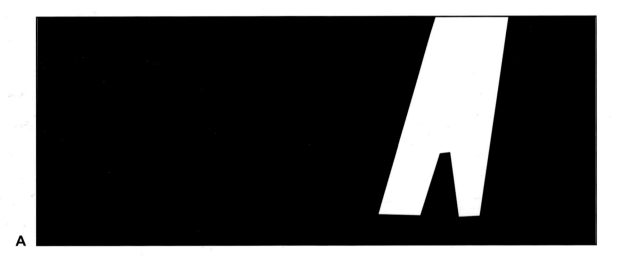

A

Once we have established a basic idea that we know will serve our purpose, what we need to do next is stick to it and use it as a clear visual statement. We know it feels suffocating, claustrophobic, dramatic, and we also know it directs the eye clearly to the main area of focus...so the choice is successful (see pages 040, 043 for similarly themed images, and pages 057, 087 for examples of how to balance the main weight of an image when one composition affects the next when it comes to cinematic continuity).

Now, to put it simply, all we have to do is draw and illuminate the image following this template. The specific situation that the story dictates will have to conform to this as we can see in the examples '**B**' and '**C**' in the next page.

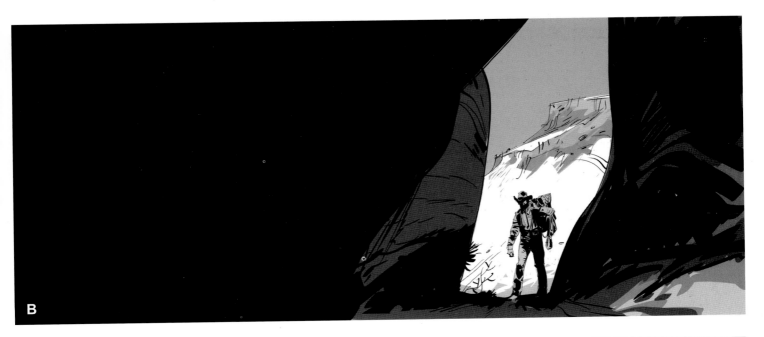

The second set of thumbnails will depict the dynamics of the image in terms of lines, whether physical or perceived (i.e. "connecting the dots"; see page 026). In the case of example '**B**' we see that the texture of the rocks and terrain also point to the stranded cowboy, adding to the drama.

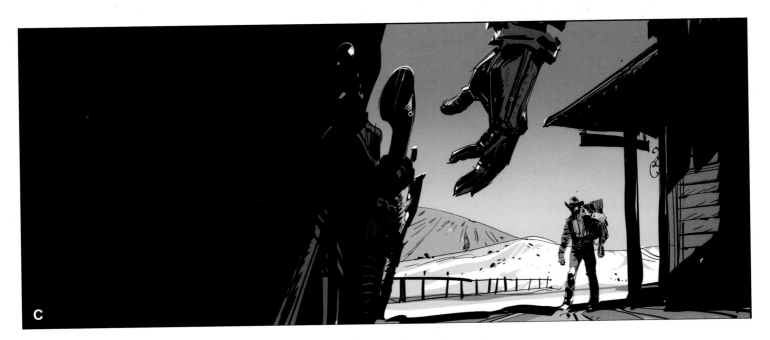

Here in example '**C**' we get physical lines like the fence, the hill on the left, and the shadows on the wall to the right, all of which draw our eye to the cowboy in the background. Additionally, there are imaginary lines created from connecting dots as seen before, like the one resulting from the butt of the pistol, the bad guy's knuckles and finally the head of the man in trouble.

Let's see further examples of how, with the proper use of lighting, staging, framing, and other elements, we can compose effective, quickly readable images to serve the needs of a specific shot while directing the audience's eyes toward the key narrative subjects of the scene.

THE RESTAURANT (A GENERAL CASE)

Let's imagine, for example, a scene in which two people are sharing a table at a restaurant. Without dialogue, we might not know exactly what is going on between the two, but the visuals will be there to tell us a lot about it.

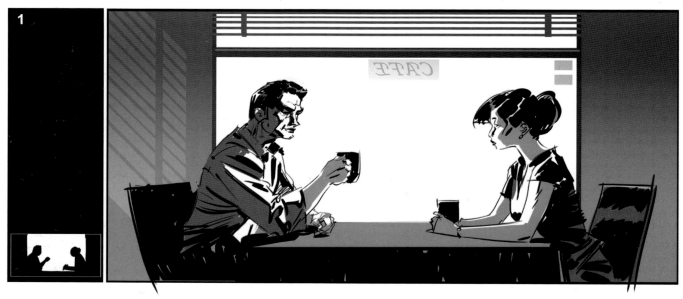

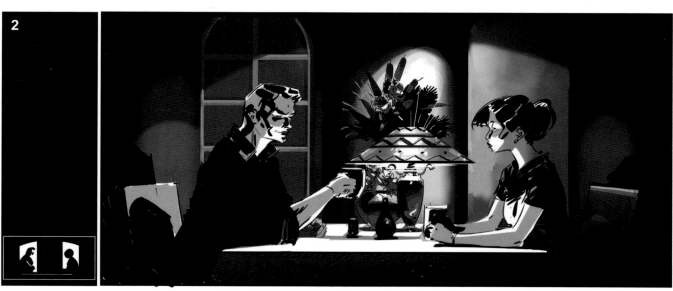

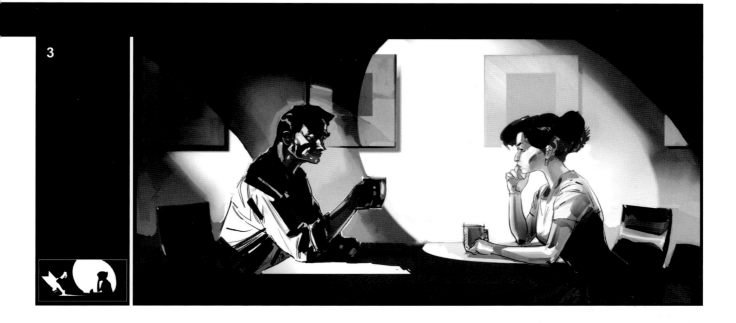

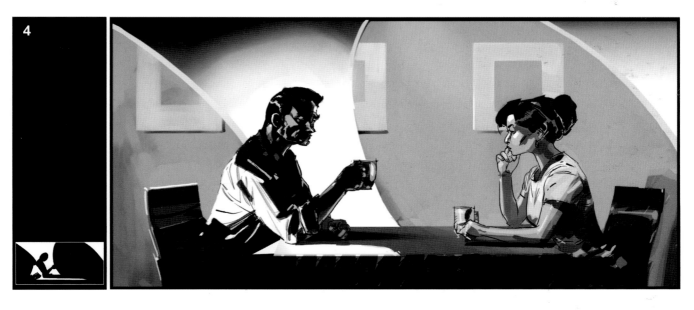

1 - If the space between them is clear of obstacles, the impression will be their communication is fluent and positive. Also, if they are both equally lit, the feeling of personal balance between the two will be emphasized.

2 - On the contrary, if we position visually heavy elements between the two characters, the visual dialogue between them will be somehow broken. The feeling will be accentuated the moment their respective backgrounds are different, literally placing them in "different spaces."

3 - If one of them is lit while the other remains in the shadows, the lit person might have more positive intentions than the one who is not.

4 - When one of the characters is lit in a way that offers a bigger tonal contrast than the other, our eye will go straight to that person (the man, in this case), giving him a bigger visual relevance.

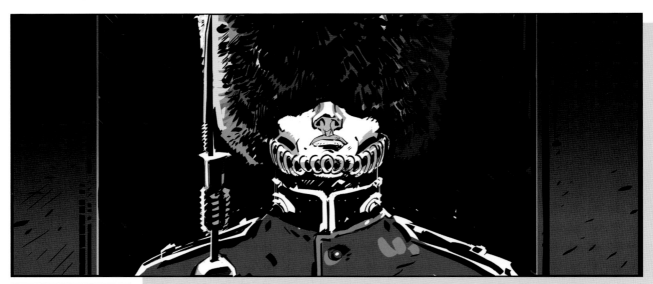

Worlds should be established early into the development of a story. The emotional tone of it, the "rules of the game," the basic frame in which the narration will unfold, is usually presented to the audience right at the beginning. In this case, a single image conveys multiple messages. Besides a specific geographical location, we also see a story that begins with a symmetrical, somehow flat and unquestionable tone and characters with a well-determined code and set of rules which will affect the decisions they make throughout the story.

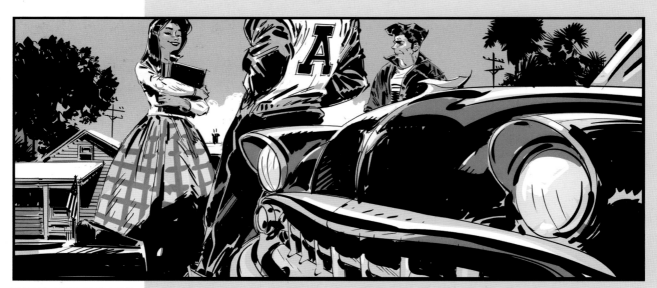

Here everything is a lot more organic and relaxed. First off, we have many more textures and depth clues in the scene, like the sense of perspective implied by the car in the foreground and in relationship to the group of teenagers in the middle ground and then the houses in the very background. The faces we see in the shot are also clearly exposed, their smiles obvious, their clothes, evidently from the '50s (same time period already established by the car), follow the individual taste of each girl and boy. All this is the world of these Southern California teenage characters, a world that sets the right mood for "the story we are about to tell."

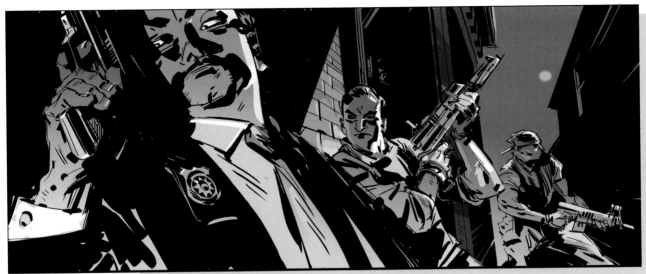

Since we are working on flat surfaces and depicting only a still frame of what is supposed to be part of a moving action, whatever we can do to imprint a sense of motion on our artwork will be essential to a good result. In this case, since the three characters are carrying guns, we have been able to use these by displaying them "like a fan," as if they were different frames of one single weapon in motion, all the way from the lower pose on the very right, up to the one held by the foreground agent at the left. Even the shadow on the wall behind him seems to follow this rule.

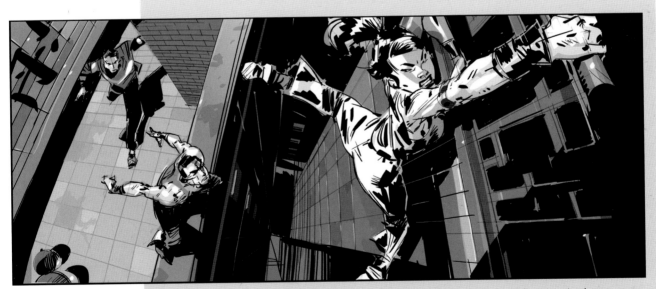

Same in this case where the three characters involved in this street chase are simultaneously taking the position that the character ahead of them was holding barely the second before. Also, if we drew a line going across their three heads, we would see it follows a U-shape direction like the one of a skateboarder sliding down a ramp, to be shot upwards by the next ramp a second later. Finally, the use of a one-point perspective downshot with a wide-angle-lens effect, adds to the vertigo and motion feel of the shot.

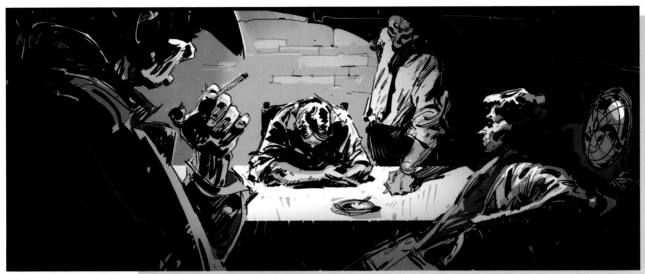

Lighting really is a powerful tool when it comes to directing the eyes of the viewer, in this case, creating a frame in the center in which we have a character being questioned by a group of tough cops. Again, all eyes are on him. Also, every other character's eyes are positioned within the frame at a higher level than his. These, together with the fact that the fellow's body is underneath the horizon line, add to the diminishing effect. A couple of closed fists in the shot in contrast with his open hand adds to the drama, as does the forearm of the character to the right and the hat at top left, both pointing in his direction. By including the shadow on the wall above the detainee's head in the shot, we "close the circle" on him—he has no way out.

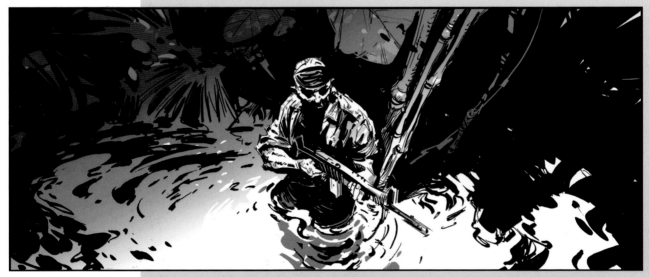

The chosen point of view here is telling us how much trouble this soldier is in. By positioning the camera high up, looking down on him, we can barely see what is around him, the same way he must be feeling in this swamp. The big leaves and palms around the soldier visually diminish his size against the environment. The bamboo canes behind him also help emphasize the dramatic sense of perspective of this downshot.

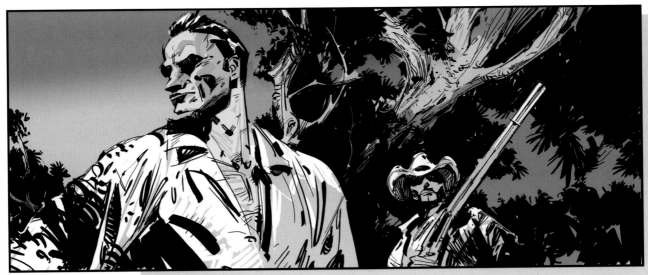

The moment we position the camera lower than the character's eyes, the subject becomes a towering, imposing figure, apparently more in control of the situation. In this case, the main figure becomes even more prominent due to the difference in size between him and the distant hunter. Other elements used in the composition help enhance the tension in the scene, such as the tree and the gun creating a diagonal to the right while the foreground adventurer is slightly angled to the left. Also, the fact that he is looking out of the frame and in the opposite direction of the other hunter makes him look more independent and epic.

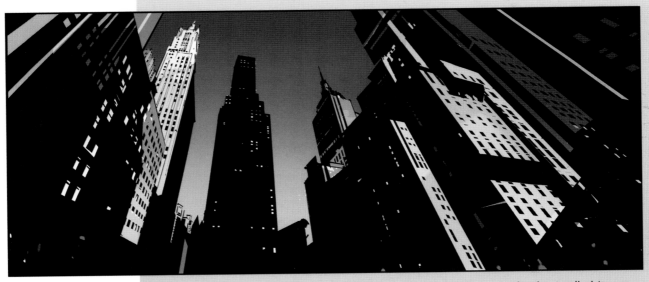

As an abstract concept, the overwhelming feel of an upshot can also be applied to any theme or subject, like the architecture of a city. In this case the wide-angle-lens effect of this scene could even be upstaged by a shot in which the camera was pointing so high, the vanishing point would be included in the frame. Another example of this concept can be seen on pages 004-005.

USING THE NEGATIVE SPACE

Negative space is in fact the surface that is supposed to be the least relevant in an image, that is, the space outside and between the elements that are considered to be the main focus and subject of the composition. But negative space can often be used as a very active part of the message. Here are a few examples.

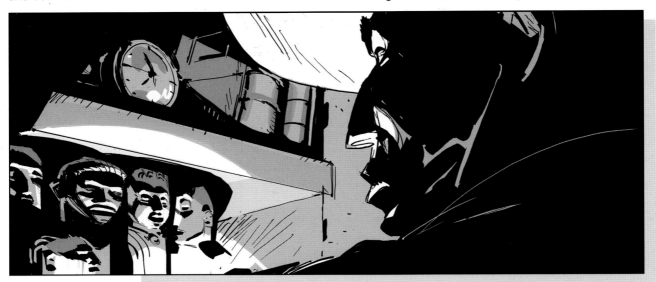

 A crook tries to steal a mysterious idol from a safe. In this case, we use the back of his head and shoulder to frame his object of desire. The atmosphere of mystery becomes enhanced by the use of a low beam of light coming from a flashlight outside the frame. The same light illuminates the basic features of his face just enough to show the tension in them.

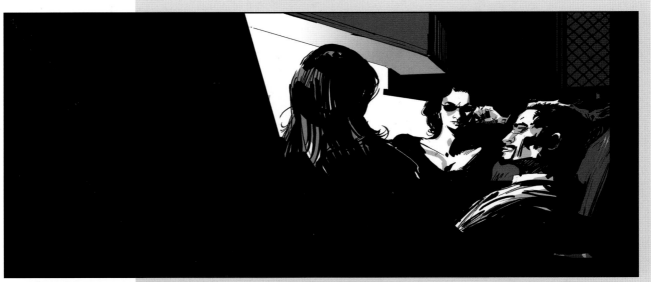

 A conversation is taking place at midnight in a room with one light source. The light source is concealed behind the big dark shape on the left so that we focus only on the surfaces illuminated by it, which are mainly the faces of the characters in the scene. The one seated to the very right becomes the center of the whole action by being the only one who reveals his eyes and full expression, while at the same time pointed at by the wall structure and observed by the other two people in the shot.

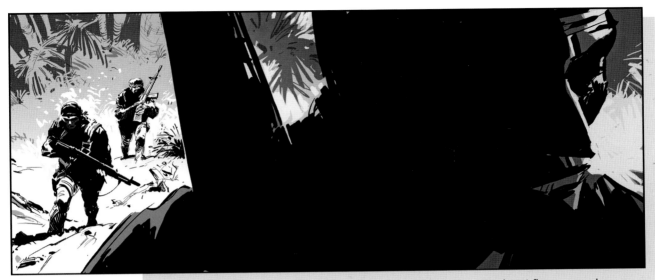

In this shot, while the soldier in the foreground is the most prominent figure, we also use him as a device to frame the other two who follow. The extreme size difference in the frame between these two groups (that can be enhanced by the use of a wide-angle lens) adds drama and tension by contrast (see page 075) to an otherwise less dynamic situation. Finally, whenever we have a repetition of similar elements in a composition (human heads, in this case) let's take into account the rhythm or "sense of motion" they create. We can visualize it by connecting these three elements with a dynamic "U" shape line.

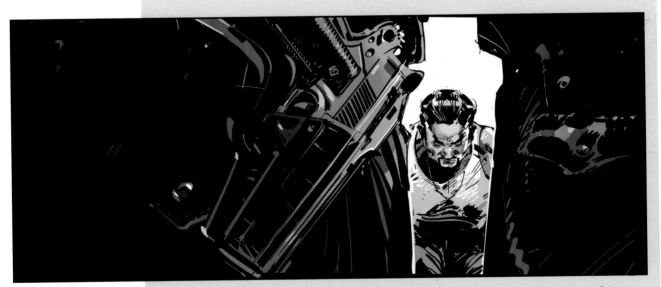

Here, an oppressive atmosphere is achieved by positioning this "arrested man" in an extremely tight frame created by the backlit bodies of the two cops in the foreground. The man becomes even more vulnerable the moment we make him the only one exposed to the light. Also the gun screen left seems to be adding pressure right above his head.

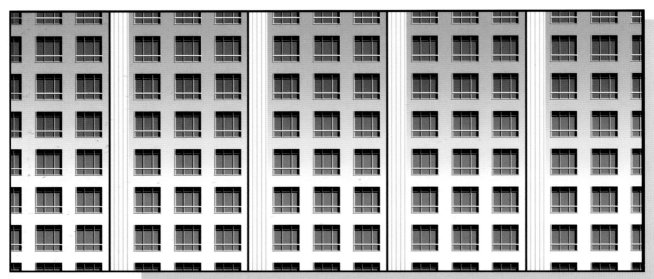

Playing with contrast in an ordered composition of elements in a frame against a more random or chaotic one produces different effects within the context of the story we are telling. Such a disposition of elements can be telling us either something about the general emotional moment or establish a leitmotif for the character the scene refers to. In the first case, we would have a rigid, cold, overpowering beat in which the characters can get lost or overwhelmed in a web with the shape of a well-structured maze. If the image represented the space deliberately chosen by the character to live or work in, all the adjectives applied to the building would also apply to him or her, defining and establishing a full personality.

By contrast, the more random and organic disposition of the windows in this facade would show a theme that could come across as more improvised, disorganized, contrasted, and somehow humanized than the previous. Also, the materials this second building is made of (bricks that are revealed here and there by an uneven paint job) emphasize the message by contrast with the hard metal and concrete of the first.

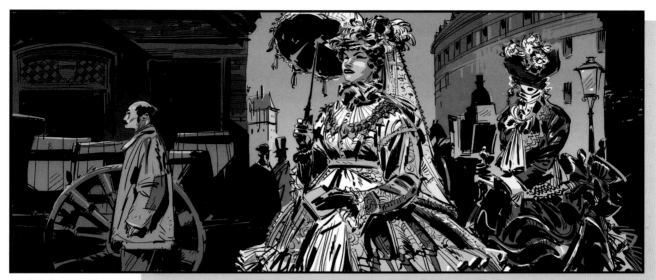

Stories are mostly defined by the passage of the characters from one state to another, this being emotional, physical, or a level of enlightenment. All this richness of textures, states, and different levels of depth will need their own visual representation throughout the story, and one way of doing it will be by playing with the contrast between simplicity and complexity. In the case above, we establish two different worlds within the same city. The detail and luxury of the dresses the two ladies are wearing clash with the rest of the scene, including the character wearing run-down, simple clothes in the background, and everything else that appears to be part of his job. One character will be able to belong to both visual worlds in the story, depending on the moment he or she is going through.

In the case of the forest, all we have in the shot are trees, but we can immediately identify one of them as special, magical, and somehow different from the rest in a way that there is no doubt it will play a role in the story, so special that it might even become the visual representation of a major turning point. Though the tree would still seem special—although in a different way—if it were an imposing, perfectly straight one in a forest of twisted trunks and branches by contrast.

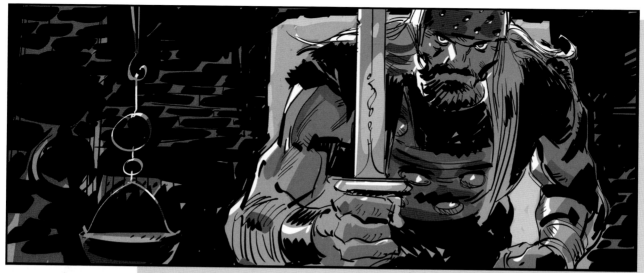

In a story we will always have characters and objects that, either throughout the whole narration or just in specific, key moments, will need to appear (emotionally) "big" or "small." Or we should say "bigger" or "smaller" than others, because the size of an element will always be such in comparison to the ones around it. In this example, we need the brutal warrior to appear as terrifying and menacing as possible, therefore he has been depicted close to the camera, so close "he doesn't even fit in the shot." Also, he has just come inside this hut through a door that might be suitable for the size of its inhabitants, but barely big enough for him to sneak in. All other objects in the house will also be drawn to a size according to the rest of the construction.

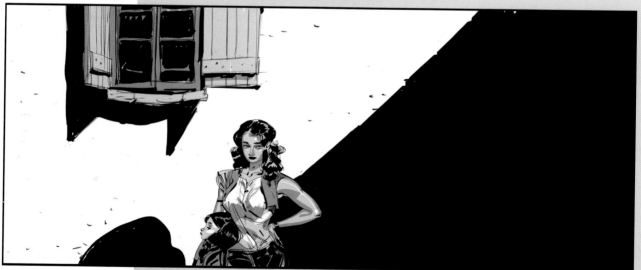

In this example, these two strong-willed characters seem to be at the mercy of the circumstances around them at this point in the story. The elements that contribute to this are their size relative to the frame (the head of the tallest one barely reaching the middle of it), the huge shadow area screen right descending in a dramatic diagonal shape toward them, visually pushing them down, as does the heavy shape of the window above their heads.

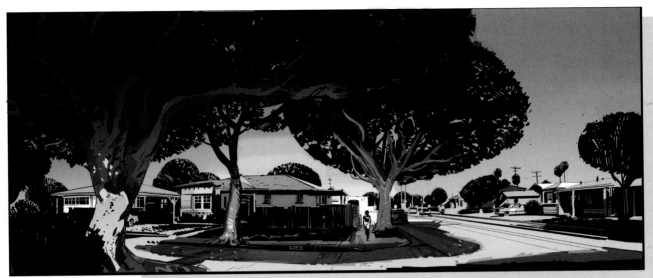

Our choice of framing can be made based on what type of line we want to favor (horizontals, verticals, diagonals, etc.). Here we see two examples based on curved (top) and straight (bottom) themes. It's a matter of establishing a line or shape language. Usually curved lines will inspire softer, more amiable environments (unless they get to be too twisted and convoluted), while straight or angular lines will in general be perceived as stronger, drier, and harsher. Whatever our choice is, by using opposing types in the same shot, or along a sequence or story, we will be creating distinctive personalities and worlds for each of the characters represented and involved in the story, so that it is clear that such difference is likely to spark human conflict the moment things get to that point.

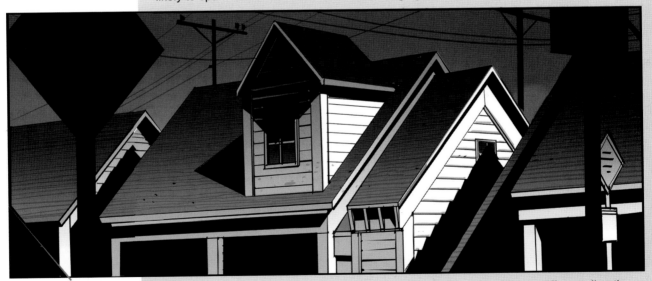

This first case plays with curves, but either by pointing the camera in a different direction or by just taking a few steps and crossing the street, the line and shape themes change dramatically, turning into a straight line and angle based on the dominated environment.

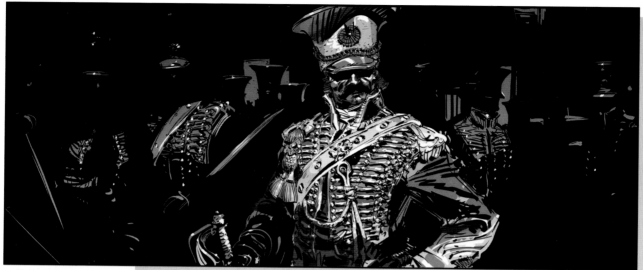

As established before, many times along a narration we will prefer to insinuate things rather than spelling them out. In most cases for this purpose, we will be able to tell a lot by showing only one or very few elements that the audience will assume compose the full image or situation. We will be able to achieve this by casting proper shadows in the frame that will reveal just enough information so that the audience instantly gets and understands what is there beyond the obvious.

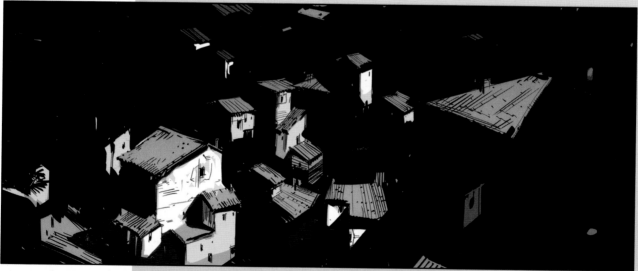

In a way by doing this, we will also have an audience imagining very complex structures where maybe only a small number of elements are clearly represented, enhancing a feeling of uncertainty that will add to the mystery (and sometimes discomfort, if required) of the moment. Such a device can be used as part of a chain of different ways in which we will represent the same element throughout a story. By showing something literally under different lights, we create a progression within the perception of it, which will establish the arc and the texture we will need in order to make our transitions and story points clear.

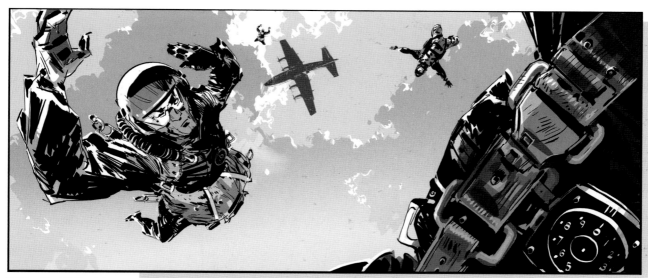

Whether drawn on paper or projected on a 2-D movie screen, our images will compress reality onto a flat surface. Although sometimes we will need to emphasize this sense of "flatness" for narrative purposes (for example, to create a "flat" leitmotif for a particular character or type of situation along the story), in general we will try to keep images within a certain range of contrast and vibrancy. This will make the imagery appear more alive and with a bigger sense of depth and implied perspective that will help make it all the more credible representation of reality.

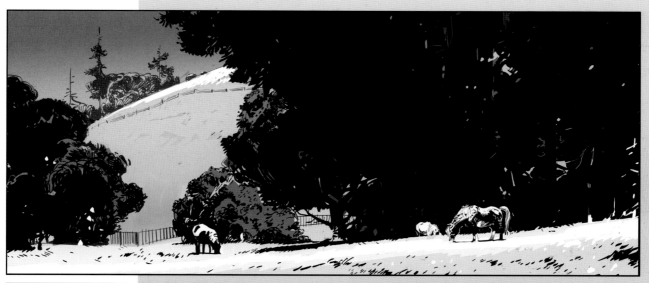

In these two examples, the compositions include the same elements (paratroopers and trees) in the different sizes "big, medium, and small." These help create the illusion of movement and dynamics, independently from the level of action represented in them: high in the paratroopers shot, and very low in the calm landscape shot. One element that makes a difference between the two is the use of spikier silhouettes ("X" shapes in both the open arms and the plane fuselage and wings) and the rounder, softer, steadier ones in the farm scene.

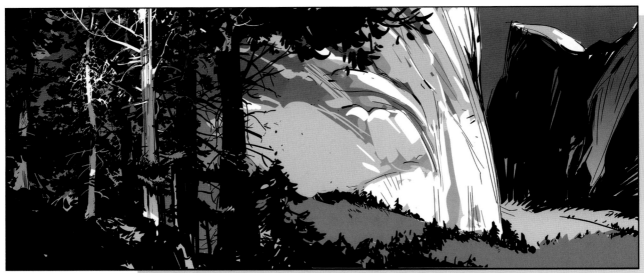

Landscapes do have their own voice and speak just like any other character in a film. Depending on the position of the camera, framing, and lighting conditions, the emotional charge they provide to the story will vary. Here we can see two different versions. While the camera is exactly in the same position, the first example is the one of a valley in which we can see and appreciate pretty much every detail of it; therefore the sense we get from it is fairly reassuring. The lighting is emphasizing lots of vertical shapes, giving a sense of the depth of the valley, but without having the potentially disturbing effect of more diagonal shapes.

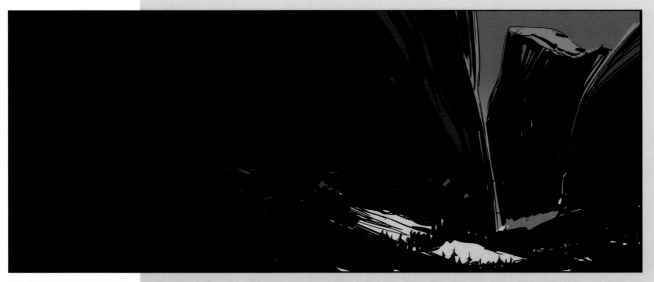

It's nighttime. Most shapes that were obvious before simply disappeared as visual elements. The sense of uncertainty we perceive is quite sharp now. The fact that the main gap between the mountains is so far pushed to the side adds to a sense of distress. As far as action within the shot is concerned, this particular frame invites to either display no action to enhance the eerie feeling, focus the action where the light concentrates for a fast read, or to simply introduce a surprise element with an unexpected, close-to-the-camera movement in the foreground left.

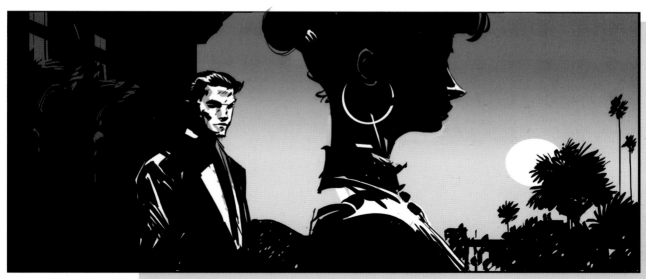

As mentioned before, the principle "less is more" definitely applies when it comes to lighting and composing a frame. On many occasions the audience will need just enough information to understand the emotional complexity of the story moment they have in front of them. If the male character in the scene is wondering about what is in the mind of his partner, we might as well put ourselves in his shoes by obscuring her expression, so that the question is equally valid for both the first character and ourselves.

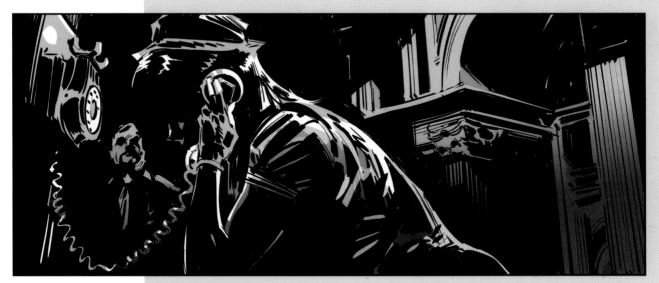

Following the exact same principle, in this case we increased the intensity a notch by positioning the camera lower and pointing upwards to create an upshot, while at the same time the rim lit back of the girl in the foreground creates an intriguing diagonal that crosses the panel from side to side. Throwing the right amount of light on the background will tell us everything we need to know about the type of location in which the action is evolving, without revealing so much that the mystery is gone. Besides this, and in order to increase the tension and readability of the shot, we see that both the diagonal shadow and the line formed by the capitals of the columns are both pointing to the area where the action is happening, also circled or framed by the telephone cord.

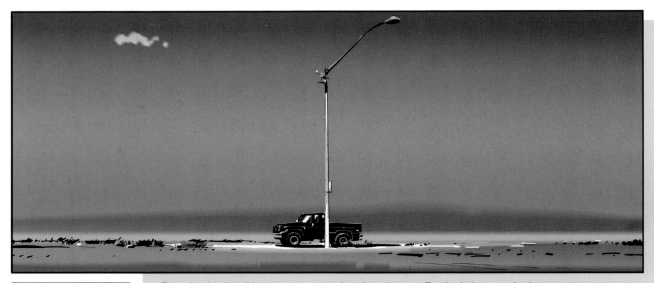

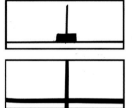

Foreshadowing things to come can be played very effectively in a movie. It can create a sense of suspense and anticipation that adds to the atmosphere and tension building that affect the whole sequence, or the whole movie, if such tension takes place right before the final and major resolution of the film, and therefore playing a major role in the outcome of the story. Eerie moods can be achieved by composing shots in weird and unexpected ways. For example, producing perfectly symmetrical compositions when they are clearly not there to play an epic function at that point, as we see in the frame above, including elements that, together, might seem out of context. Many times this effect can be achieved by simply cropping out other elements that are in the area and, if shown, would make the scene appear more natural.

Cropping an image can be achieved not only by camera work (simply by not including things in the frame) but also by lighting, visually leaving out things that otherwise would be clearly stated as part of the scene's message (see page 019). Moreover, in this case, the perceived image is taken to an extreme position within the frame, which makes the image appear as more unnatural and therefore includes a sense of unpredictability.

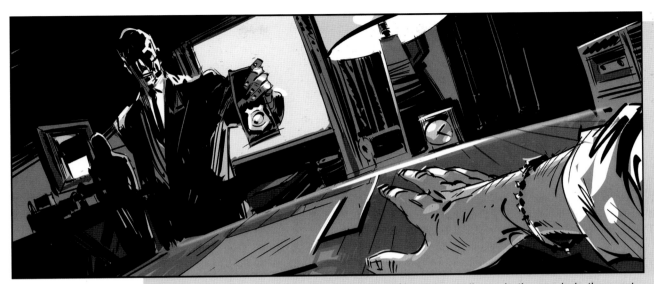

POV or "point of view" is a device that lets us put the audience in the movie in the most direct, physical way. By putting the camera where one of the characters in the scene is, we will see things the exact same way the character perceives reality around him. In this first case, we can tell the subject of this police investigation did not have a nice time waking up from his mid-afternoon nap. The backlighting effect emphasizes the confusion of "his" moment, as does the tilted camera angle in contrast with the "vertical stability" of the two cops sent to arrest him.

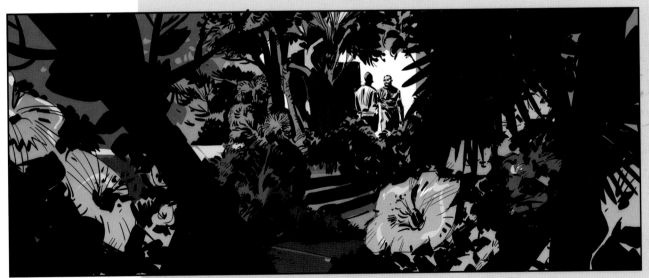

A voyeuristic approach here is taken by locating the camera behind the bushes in this house garden, and framing the two characters involved in a secret conversation with many layers between them and the lens. This way we create a sense of being in a concealed area, trying not to be discovered, while attempting to figure out the details of such crucial conversation. Notice in this case, in order to get a fast read given the complexity of the image, the hottest spot is the wall right behind the characters, which also includes the only real straight line in the whole image, the frame of the door.

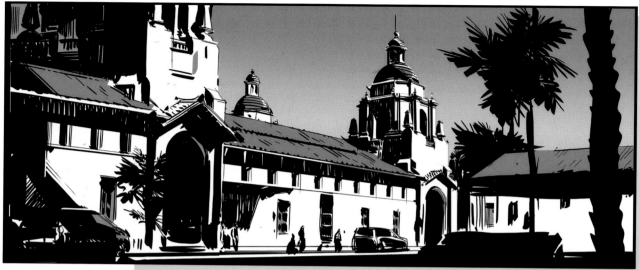

When it comes to depicting different times of day in a drawing, there are two things to take into account: the light source and the way the light source reflects on the elements in the scene. Our priority will be focused on the latter in order to establish clear differences. We see in these two examples how the skies have the same exact value (alright, except for the moon!).

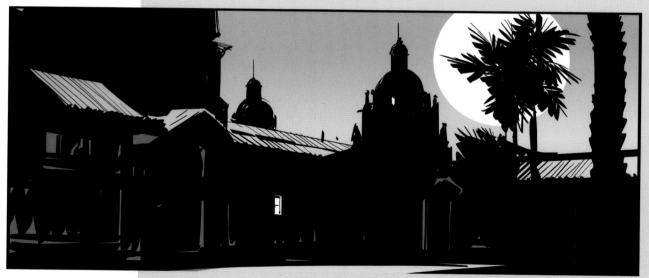

The fact that we obscured every detail in the second panel (and we could have gone even further with that), flattening every detail in the location to the point that everything becomes pretty much a black, graphic shape, gives the fast read of a nighttime shot. Going back to the daylight shot in the first example, we appreciate not only a majority of lit areas, but also the depiction of reflected light in the shadowed areas, reading as a situation in which "light" is the predominant overall element in the shot.

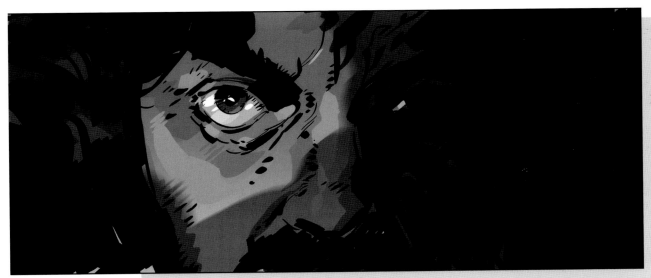

A movie projection screen is a really big surface and, if a filmmaker is to make sure the audience doesn't get lost in it during the narration of the story, it will be an essential task not only to direct the eye on the screen's surface in every single shot, but also to make sure the eye doesn't get lost whenever we move on to the next scene, having to look around forever to find our next focus of attention. There is no time for it, and there is no reason for it to happen. One of the devices we will use for this is a very simple one. Make sure whenever possible and convenient for the narration (see also pages 057, 087) that the last position of the focus of attention in one shot coincides with the first point of focus in the next shot, as seen in these two examples.

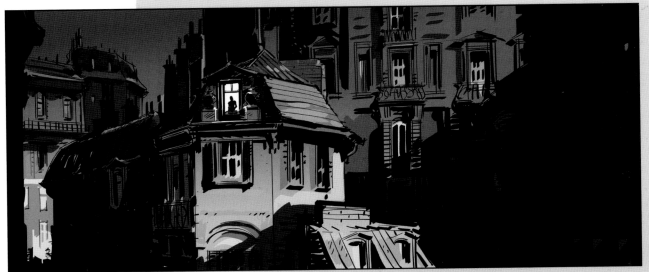

Here we use compositional elements such as pools of light framed by shadowed areas as well as the rule of thirds. But still, if it weren't for the identical position of the characters in both frames (the eye leaves us where the lit window appears in the next frame) it would take us a while to find what window of what building we should be looking at. By the time we did find the intended focal point, the shot would have lost its meaning and purpose within the story.

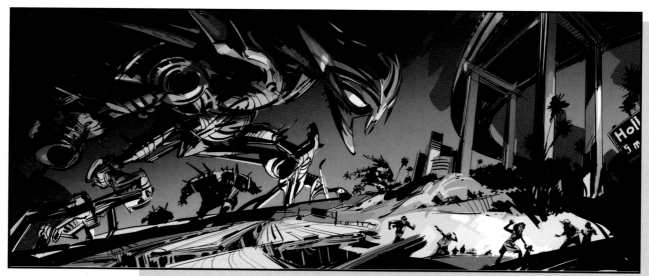

The shot above clearly establishes a sense of scale between the rampaging aliens and the humans running for their lives in the midst of total chaos. The aliens already look huge from our point of view. Let's imagine then that, within the same shot or in adjacent scenes, we later focus on formations of such creatures marching past camera back to screen left where they originally came from, returning to their mother ship which is waiting for reports on the invasion...or simply going back to their base for refreshment troops.

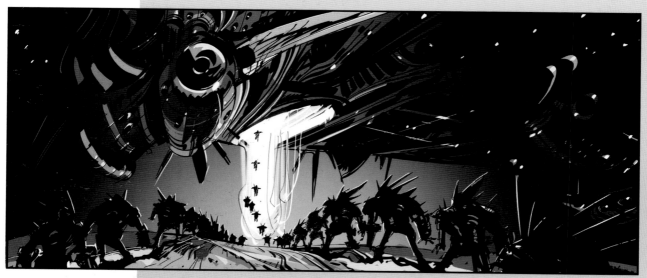

We would end up eventually with a shot similar to this second one. The result is that now we can see how huge the spaceship must be in relationship to the humans after we compare it with the common element within the two frames: the aliens. And by establishing a physical point of contact between the aliens and the ship's huge opening where they are being pulled back inside, we reinforce the scale comparison between the two very clearly given the overlapping (or contact) area.

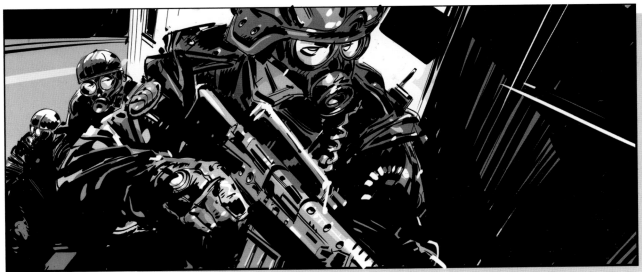

Rhythm in the cutting plays an essential role in filmmaking as it does in the graphic novel (page 114). Emotional effects are not only achieved by the images themselves but also by how these interact with each other on the screen. The way we do it in this case is by manipulating the contrast between two different levels of tensions. The cops in the first frame are taking the initiative; they know (as we do) what is going to happen in a matter of seconds, even if they might not be certain about the outcome of the operation. The crook, on the other hand, is completely oblivious to what is going on just a few feet away from him.

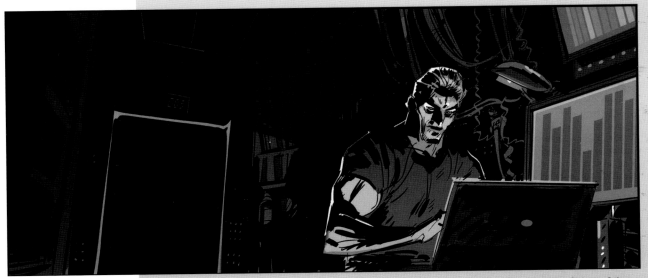

The fact is, the audience now has full knowledge of what's happening on both sides of the door. To combine these two shots successfully we, first of all, made the policemen bigger in their frame than the crook is in his, to visually show who is more in control. Next, the eyes of the first cop in line are higher in the shot than the bad character's is in his, so the moment we cut to him our eyes will have to go down to the crook's, establishing a power and control relationship between the two sides. And lastly, we placed the characters at opposite sides of the screen, so that it is clear that the first characters are visually—and literally—chasing after the second.

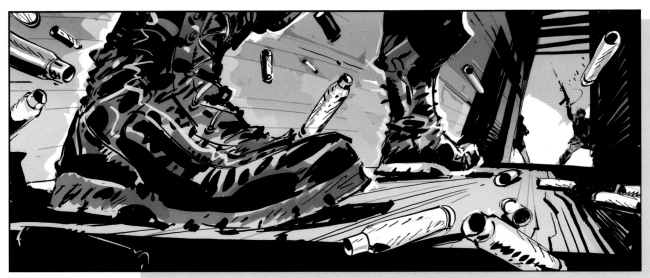

There is value in not going for the obvious, for the actual center of the subject matter, but for what is around it instead of for the action itself. The consequences or reactions to the main action can, on many occasions, be a more subtle and powerful way to explain a situation or number of circumstances. In this first example, the use of a wide-angle lens forcing the perspective, the amount of shells chaotically falling on the floor, and the camera being so close to the foreground soldier, might explain the electric tension of the moment better than a more straightforward option would.

Consider depicting an encounter between a spy and his contact who have never seen each other before. Beforehand they agree on a specific signal or distinctive piece of clothing or item to be worn by one of them. The best option would be to concentrate on that signal or item and to exclude faces, expressions, architecture, or other surrounding elements in the frame that might just get in the way of understanding that, as an audience, now *we* are this spy looking for that marker, adding to the tension of the moment by fully identifying with him. This also allows us to focus more on the contrast between the impatience of the waiting one versus the calm of the other.

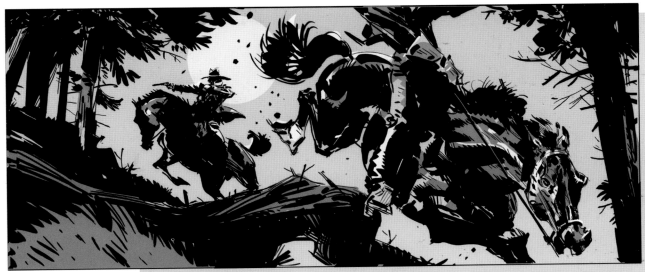

Action shots are mostly defined by dynamic shapes and compositions based on diagonals, either going all in the same or opposite directions. Diagonals and tilted camera angles are associated in our minds with a sense of instability, of something going wrong, and therefore alarm. In this case both horses depict diagonals with similar angles or directions, while elements—like the body of the horseman in the background, the arm of the one in the foreground, and some of the trees—take off in an opposite direction, adding to the effect. While a still action shot like this one tends to work this way, other considerations will come into play when we have a sequence of them working in continuity, like creating tension by fast cutting of the shots, playing close-ups against long shots, and basically using contrast to heighten the drama (page 075).

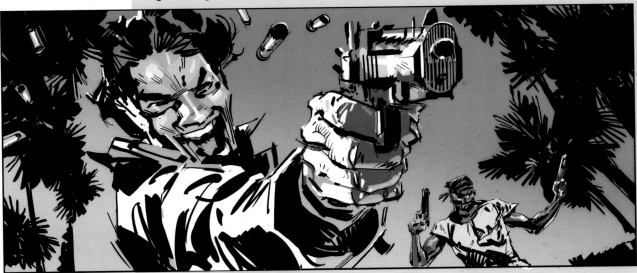

The intensity of this shot is created by several elements: the dramatic difference in size between the two characters, the tilted angle of the camera, the upshot position of it, the tense expression of the main character, the explosive silhouette of the palm trees in the background, the chaotic and random angles of the shells being expelled from the gun's chamber, and the proximity of the menacing weapon to our faces.

We have seen until now how the elements in a composition and their distribution within a steady field create many different emotional and dramatic responses in an audience. But what happens the moment these elements start moving significantly, and changing the composition one or several times within the same scene? Or what happens when the elements are steady, but it is the camera that is actually moving?

Camera movement within the set / Camera motivation

Let's take a look at the example on the following page.

We are now at a *train station* where a female agent wearing big glasses is spying on an older gentleman who happens to be a scientist in possession of some super secret formula that *must not* leave the country.

Sometimes, depending on the rhythm of the moment in the narration, we might choose to go directly to the characters and the specifics of the action itself. Other times, we might feel we need a little introduction to the moment, giving at first the impression that not much is happening there, and all of a sudden we show the audience that things are more complicated than they appear to be.

In this second case, we could end up with something like the example on the next page.

First, we take off from pose '**A**.' In the very foreground we have a character who, despite being so close to us, we manage to turn into a secondary character, just by covering his face and expression with a hat and its shadow, so that he is "part of the composition but not of the story."

At this moment a young lady and her son show up in the scene walking left to right, motivating the camera to do the same, so we can get to '**B**,' our final destination in the shot, following a natural flow of events. Also, the lady's head is turned away from the camera so that she as well becomes secondary to the narration.

If we look at the long second drawing on the page, we notice that all the faces in the hall are turned to screen right so that they follow the general sense of motion as well—that is until we get to the old scientist at the end of it. He really is different, special, and essential to the shot, visually explained by the fact that he becomes *the* element of contrast in the whole lineup.

And then we get to camera pose '**B**.' At this point the only two characters we need in order to understand the action are in the shot. The special agent is very close to the camera so that we can understand and perceive every nuance of her acting, at the same time creating more tension simply because of the large percentage of the screen surface she occupies.

Finally, we need to make sure that the composition of both architectural elements and people in the shot offer a good and readable composition at any point between '**A**' and '**B**' that we decide to freeze the frame.

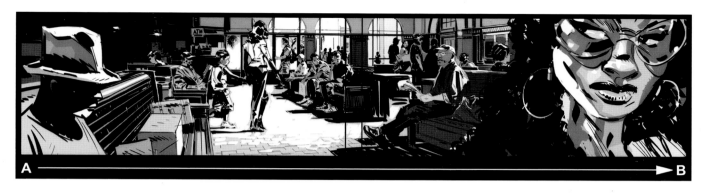

A ──► B

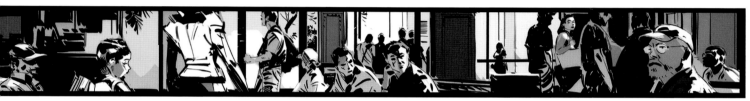

A

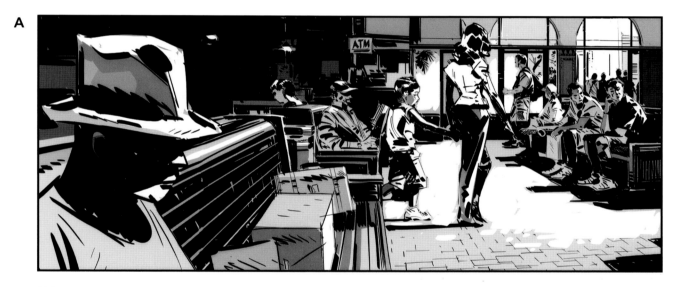

B

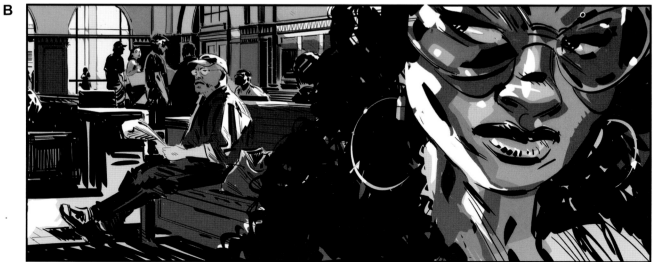

An *epic shot* is the subject of this next example.

In this case the chosen format is a vertical one, far less mundane than the previous horizontal motion. As with all camera pans, its different frames or camera poses represent a different moment within that beat of the story.

We can easily imagine the sublime, menacing, or calm clouds in the first frame to be the backdrop for a character or story mood presentation, with or without a voiceover, to then move down to the next emotional moment.

In the previous scene, it was the direction in which most of the characters were looking, as well as the direction of the motion of the lady and son, that were motivating the camera's movement. In this case, it is basically the gigantic vertical shape of the spears that brings us down from the poetic and symbolic frame 'A,' to the more earthly but at the same time epic feel of frame 'B.'

Visually, the different widths of the masts in the foreground left help us obtain a sense of texture and perspective that—despite simply being flat, graphic, and barely silhouetted shapes—tell us a lot about the strength and potential danger involved in the situation.

Other elements also contribute to make a very clear statement as to who is the important person in the scene. The soldiers on the left (and even the two to the right) are in a group, their silhouettes mostly overlapping one on top of each other, while the big lord is detached from all this, to lead and live his own story. Plus, no head is higher in the frame than the one of the "noble character," him being the only one on horseback. And while the others seem to be idle, he is the only one in motion, an uphill motion, indicating that nothing he has achieved or will achieve is effortless, enhancing his greatness as an epic personality. Also the helmet and armor the horseman is wearing are a lot more ornate and sophisticated than those of the foot soldiers.

As for the clouds, they follow a downward motion and a left-to-right path, somehow pointing at the main character while also providing a shiny and overexposed backdrop for his dark presence in frame 'B,' offering the highest contrast in the whole scene. To enhance the drama and somehow the balance of the composition (page 075)—balance here is good since we are not yet at the climax of the battle, and we will need somewhere to go from here in order to eventually enhance the visual tension of the situation—the subtle diagonal shape the clouds create and the one depicted by the spears are opposed, counteracting each other's dynamics.

And finally, we again will take care of turning 'A,' 'B,' and any frame in between into a nicely composed shot that will serve the narrative purpose of the story at that point.

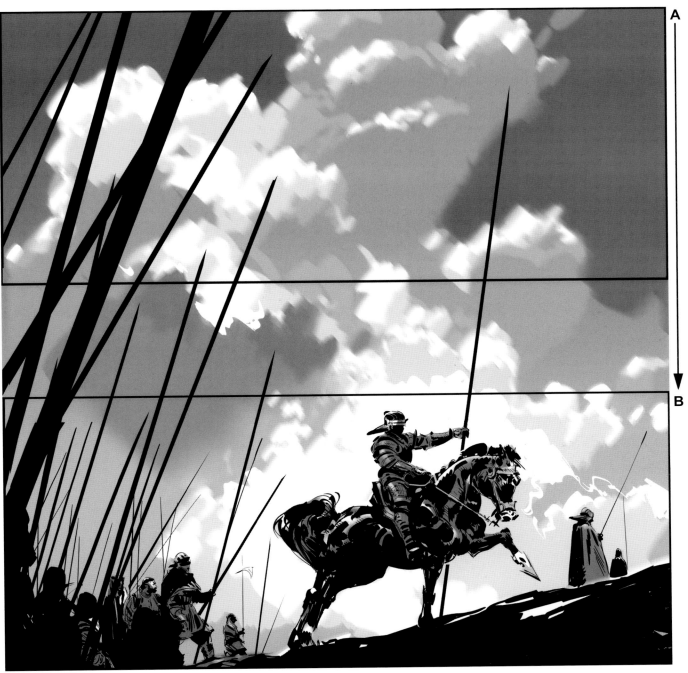

Lighting focuses image on horseman.

Diagonals created by the spears oppose the one illustrated by the clouds, counteracting each other and creating balance.

Moving the camera through a set can be used to emphasize not only the action but also the **changes in mood** the story needs to communicate at any given point. The following example keeps a very similar and constant composition of the characters within the frame. We should pay particular attention to the art direction work, the way in which the environments were designed or selected and how they play their part within the sequence. The scene takes place in Shanghai in the early forties. A young male character pays a visit to the owner of a house to discuss some business. The four shots we see here are frames that belong to a single camera take. No cuts.

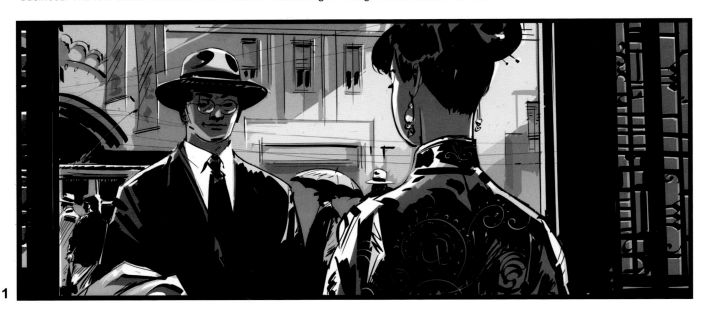

1

Once we have composed the characters in the frame, the camera will pull back slowly so that their position in the frame will barely change, establishing the perfect scenario for them to deliver their lines. These lines will express subtle mood changes along a discussion that will keep gaining intensity.

FRAME 1 The camera frames not only both characters, but also the lively street exterior in the background. People go about their business and the morning is nice and sunny. All seems right.

FRAME 2 Still an exterior, the sunlight enhances the beauty of the garden in the house's front yard. Nevertheless, we have already stepped away from the loud street to come into a more private environment. With less distractions around, the conversation now also feels less casual.

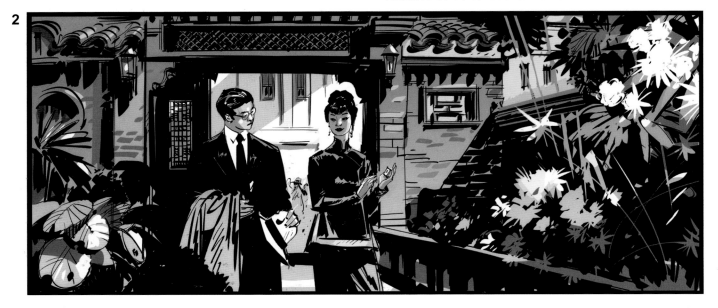

2

FRAME 3 It looks (literally) like somebody said something that created a slightly new level of tension within the situation, something unexpected perhaps, that changed the relationship between the characters at that very moment. We enter a new story beat at this point. Emotions have changed and so did the visuals that support the unfolding story. Given the fact that the room we are entering now is much dimmer and darker than the exterior we are coming from, it seems obvious that things are turning a bit more dramatic now.

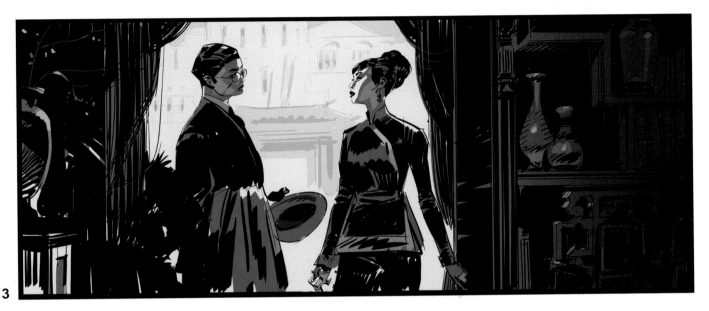

3

FRAME 4 The environment is changing again and we are now in a hall that we perceive as both subtle and complex, just as the next part of the character's conversation will be. At this point we could emphasize or downplay the contrast between light and shadow depending on our needs. We could also light the characters' faces in ways that would either offer us a clear read of their expressions and emotions or simply show them as dark silhouettes backlit against a window. As always, the possibilities are wide and complex. They are there to help us emphasize every beat and story moment, within the sense of continuity and subtlety of a scene, that despite being shot in different parts of a location, is done within a single camera move.

4

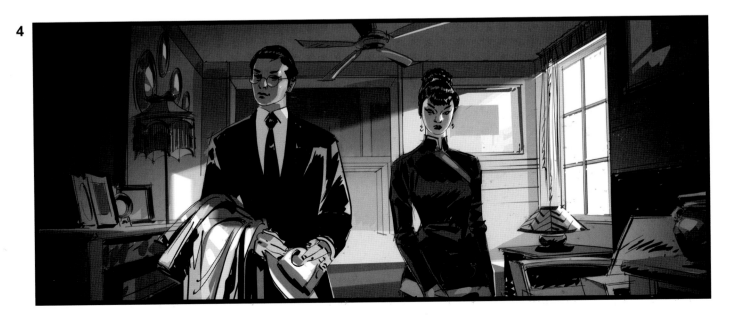

Moving the camera in certain ways can help us eventually *reveal* information that wasn't in the original composition to start with, and therefore change the mood, intensity and meaning of the shot completely. Let's see in the following case how we achieve this by rotating the camera around our central character. This scene takes place on board a ship which has just arrived in New York from Europe in 1910.

FRAME 1 Our attention centers on the face of a tired woman holding her baby tightly. She is part of a large group of people that has shared the intense journey with her but, at this point, we will exclude most of these other faces from the shot in order to focus on her story. It is *her* journey we are following and we want to state this clearly and intensely. In this first frame she is looking up and screen right, and we are not going to cross this line of connection between her and whatever she is looking at (see graphic next page, and full explanation on page 089).

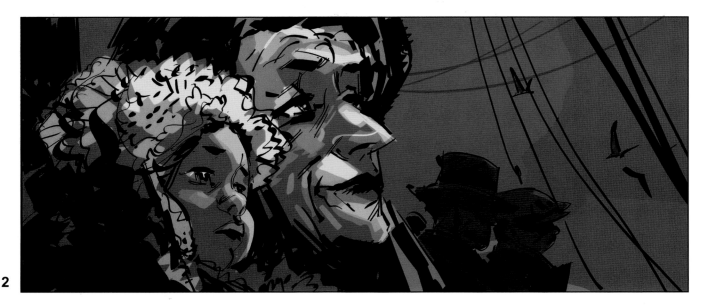

FRAME 2 We keep descending towards her and swing around the right side of her face. Again, her figure will always favor the left side of the frame and she will be looking screen right. The other characters we show momentarily will be in a darker area and looking straight ahead or away from camera, but not towards it as that might distract the audience from our main character.

3

FRAME 3 Now we are lower than her eye-level and, as we keep rotating the camera, interesting clouds and lighting start to appear within the frame (whether in animation or live action, accents like this can easily be designed and incorporated into the film) becoming part of a designed emotional transition.

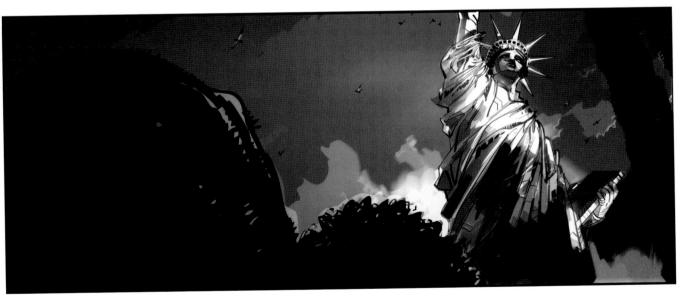

4

FRAME 4 Finally the connection is made between our character and the object of her gaze as the Statue of Liberty comes into view. The transition from downshot on their faces in Frame 1 (see also page 040), to a solemn and revealing upshot (page 041) gives us a visual crescendo that adds new meaning to the story moment and provides a turning point to the narrative.

The diagram at right shows a blueprint of the camera move. The motion goes from downshot to upshot never crossing the line and therefore always keeping the characters screen left and the statue screen right.

Another common case is a shot where the **camera is locked** in the same position while different actions are taking place, one after the other, on the very same background.

It is essential in this case to do good preparation, taking into consideration *all* the key character poses you are going to need in order to narrate the scene, and to make sure, before establishing the final framing and perspective, that any character or combination of characters we might have within the frame, at any time, *will constitute a clear and well-arranged composition*.

In this "argument at the diner" case, the choice has been to put the camera close to the height of the waitress's eyes, also getting a good framing on the trio even when she is not in the shot, for the following reasons:

- As far as *the trio* is concerned, we see that they are the steadiest element in this composition (they in fact cause all the "drama" in the scene). The other two characters are, at one point or another, moving up and down, back and forth, or not even in the frame at all. So having the scene visually evolve around the trio is a must. For this reason, all lines converging to the vanishing point are pointing toward them while, at least at the beginning of the scene, the spotlight is on them too.

- As per *the waitress*, by having her eye level coincide with the horizon line, we make sure that no matter where she stands within the location—unless she decides to stand up on a chair or jump up and down—her eyes will always stay within frame, letting us follow her acting at any given time.

- With the *lady customer* at the bottom left of the frame being so close to camera, it would be easy for her to get a lot of unnecessary attention at first, therefore she has been obscured, so that we don't have to pay attention to two different steady focuses at the same time (the "trio" and herself). For that, we simply turned her head to the left and away from the action. We see neither the features of her face nor her potentially changing expression so that she doesn't interfere with any of what is going on. Also, lighting wise, she has been located literally out of the spot light.

Other compositional elements taken into account include:

- The shopping bag on the foreground seat, in order to break the big, empty surface of the back of the restaurant bench, which otherwise would be a flat, senseless surface facing the audience.

- Positioning the side of the front seat off center in the frame. Splitting the image in symmetrical halves here would kill the composition.

- Framing the far right side of the shot in a way that we see enough to appreciate that there is more restaurant space on that side, giving a better sense of the location, but not showing so much that it becomes distracting by leading the eye off the limits of what is important to the story moment.

- Being a night shot we can easily concentrate all light inside the location. If the case was a daytime shoot, we could draw the blinds down, have a cloudy, rather dark day outside, or simply choose an uninteresting landscape outside as a backdrop.

- As we see on the next page, manipulating the lighting slightly, by favoring one set of characters over another, depending what is needed for the moment. This device should be used subtlety enough so that it doesn't become distracting to the action.

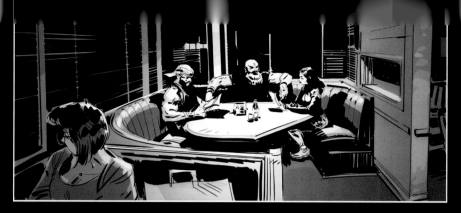

Three "road warriors" are relaxing and having a good time at the diner while using "inappropriate" language.

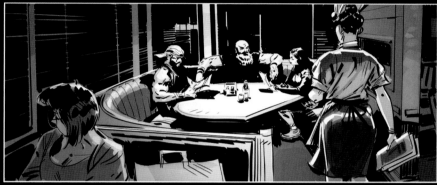

The waitress comes in to take their order.

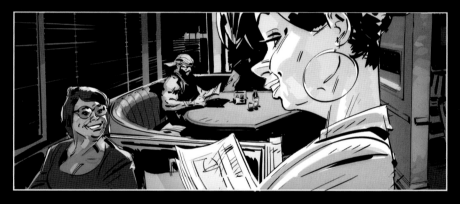

On her way back to the kitchen she stops and takes the foreground lady's order as well. They connect.

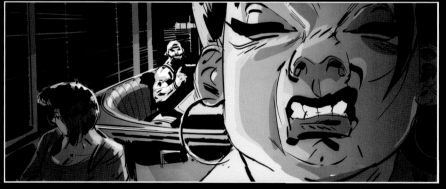

When heading back to the kitchen the waitress has to hear an unpleasant remark by one of the characters in the background.

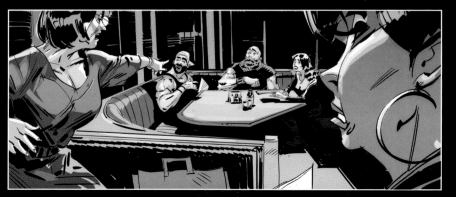

The customer in the foreground has had enough of them and decides to take matters into her own hands.

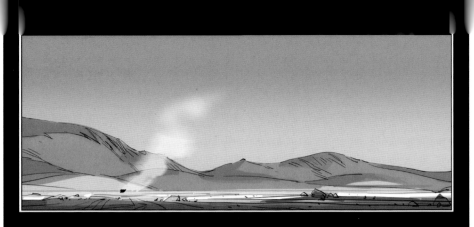

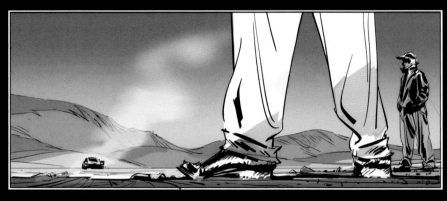

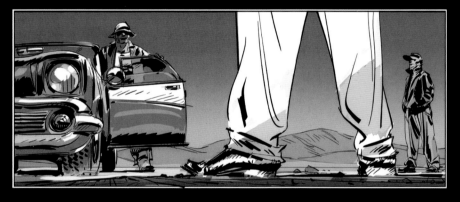

See next page's diagrams and explanations on how to dealing with a ground plane so close to camera level.

This time we need to depict an unpleasantly overwhelming feeling, the tension involving a meeting of shady characters in the middle of a desert.

In this case, we decided to lock the camera in a very low position so that the events will always feel overpowering to us. Unless we need to dramatically change the perception of things at some point in the sequence, we would maintain the camera lower than the character's eyes to be consistent with the atmosphere established in the beginning.

From frame one through three, we see a progression that makes our reaction become increasingly tense at the same pace the car in the distance approaches.

1 - From a low camera angle, the grand desert stage is dominated by a big sky. Suddenly this apparent peace is slightly disturbed by the entrance of a vehicle in the scene.

2 - As the car approaches, two characters enter the shot and take positions in the frame that in terms of distance—and therefore size difference—will increase drama.

3- Now the once-distant car has stopped in a tenuous position by the two standing men, triggering in us the perception that its driver is surrounded and therefore in a position of inferiority.

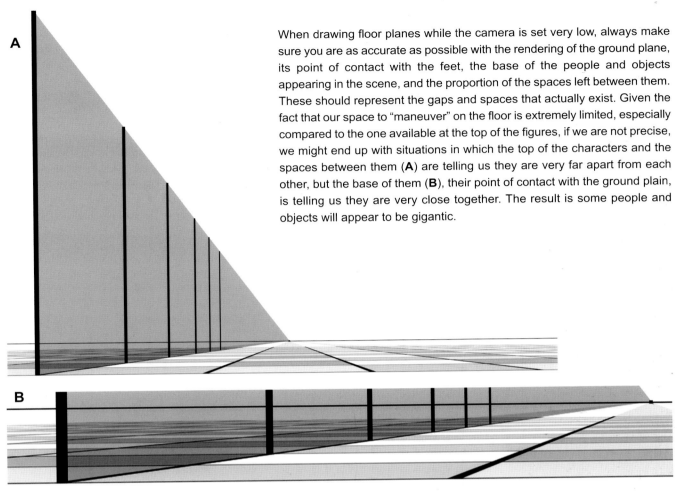

When drawing floor planes while the camera is set very low, always make sure you are as accurate as possible with the rendering of the ground plane, its point of contact with the feet, the base of the people and objects appearing in the scene, and the proportion of the spaces left between them. These should represent the gaps and spaces that actually exist. Given the fact that our space to "maneuver" on the floor is extremely limited, especially compared to the one available at the top of the figures, if we are not precise, we might end up with situations in which the top of the characters and the spaces between them (**A**) are telling us they are very far apart from each other, but the base of them (**B**), their point of contact with the ground plain, is telling us they are very close together. The result is some people and objects will appear to be gigantic.

As far as depicting irregular floor planes is concerned (**C** and **D**), the use of tonal differences in combination with depth clues—lines imitating perspective, objects we assume are of similar volume or size appearing consistently smaller as the landscape becomes more distant from the camera position and so on—will help achieve a believable sense of depth and distance.

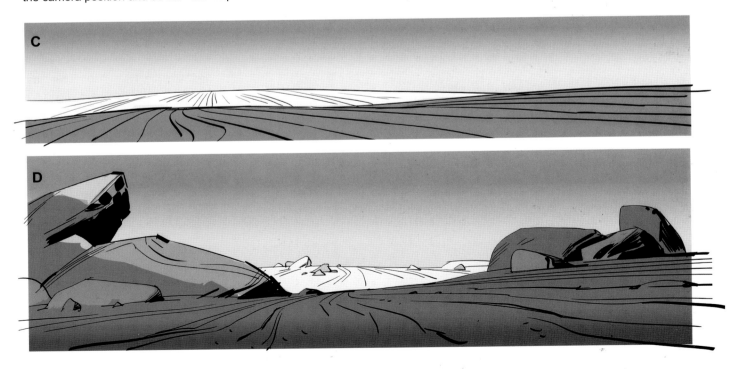

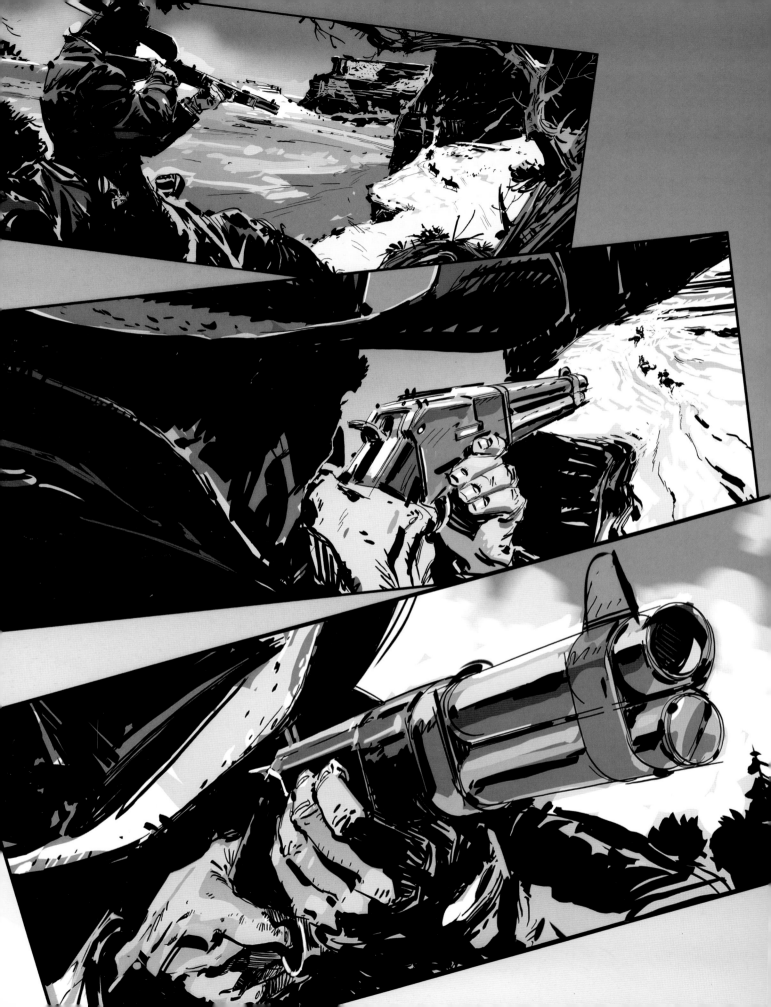

CHAPTER 4

COMPOSING FOR CONTINUITY

Why build up to a climax?

Contrast

Contrast is basically the reason why we see things and therefore why we are able to react to them, and *it applies to both the visual and the storytelling* sides of our trade. But to use a visual example first, let's say that if a room is completely dark and no light hits on the objects in it, all we have left is pitch black. In this case, we just won't be able to distinguish one object from the next, shapes and outlines will be simply unrecognizable.

Contrast, or rather the lack of it, is also the same principle by which military camouflage works. It simply breaks the silhouette of the soldier until no clear outline or contrast between him and the surrounding environment is left—we lose complete visual track of the person.

Again, let's imagine a wall painted with a very light shade of gray, so light that it appears to be white to us—until we paint a section of it in true, pure white. Then we realize how "dark" the original color is, to the point that we won't believe we couldn't see it before.

These are all examples of how *contrast makes or breaks*. It has the power and the "mission" to reveal and conceal, and it is therefore a tool that we will use to make our artistic and narrative points and statements throughout a story.

Obviously *the same principle applies to the story* our art is based on. Using contrast, we will create the vibration and the expression needed to make a story interesting. An action scene will appear to be more intense the moment we sandwich it between two quiet scenes, and a good character will turn great in our eyes the more evil his or her opponent turns.

Contrast works by making one thing distinguishable and different from others. For this, we will first establish a *rhythm* with all other objects or facts before and after, so the "special" element or event can break it.

The climax

We also use contrast to *ramp things up to a climax*, leaving *the wildest and most powerful for the end*. This is what will make the audience stick to our story. As curious creatures, we have the tendency to explore things and situations while looking for answers to the many questions, big or small, that we run into every day. Therefore, the moment we have all the answers or solutions to a problem, the moment we know or assume we have nothing further to learn from a certain situation, we tend to forget about it and look for the next challenge.

That's why in general we want stories to push us to a climax, that point we know we are really close to the answer. After the situation is resolved, the tension of having to come up with an answer is gone, the problem is completely resolved, and we finally focus our attention somewhere else.

Let's now see examples of how to visually increase the intensity throughout a scene or a sequence.

These are fully rendered images in which we can appreciate the detail, the subtleties of the lighting, the acting of the characters, and so on.

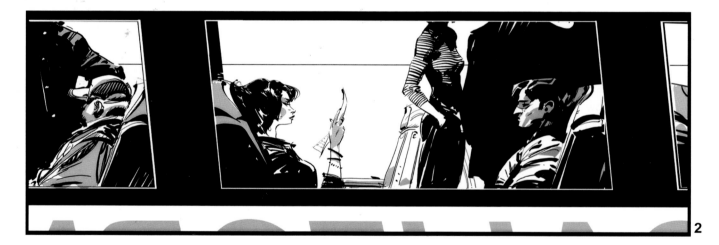

But the moment we forget about the details, specific actions, and the drawing style, we will only see the bare facts: what we would perceive if we walked into the movie theatre or opened the graphic novel right at this point, all of a sudden, *before we even realized what was going on in the scene*, what the characters were doing, what the landscape looked like, or even what time period the action was taking place in.

What would this first impact be like then, and what would it be telling us?

1 - This is just a flat line. Nothing too extreme or dramatic can come out of this uneventful basic shape. So the impression would be a peaceful, relaxing one.

2 - Things are getting more interesting here, shapes are more uneven, although we can't tell they are too crazy or dynamic yet.

3 - We also have slight diagonals, which are more expressive, but what gives the image the extra shot is the proximity of the character's face, which allows us to follow her features and acting with a lot more intensity, raising our level of participation in the action. To increase the effect even further, we could also introduce the motion of power posts or other rhythmic elements passing behind the character on the other side of the train.

Basically, while staying with the camera at the same spot all the time, we managed to heighten the tension in the scene by getting closer to the subject and progressively coming up with more interesting abstract shapes.

Also, by basing our work on such simple shapes, we manage to produce images that, no matter how complex they can get in terms of acting, detail, number of elements appearing in them, and so on, they will still be a fast and clear read for the audience (page 034). When trying to follow a story and move fluently from one frame to the next, this is essential.

Let's now go to the next case.

Let's take the same example of a traveling train, but now from a different point of view and using different elements.

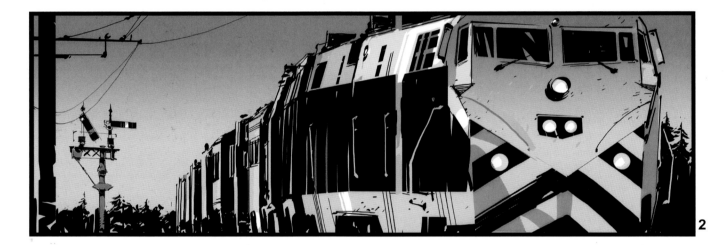

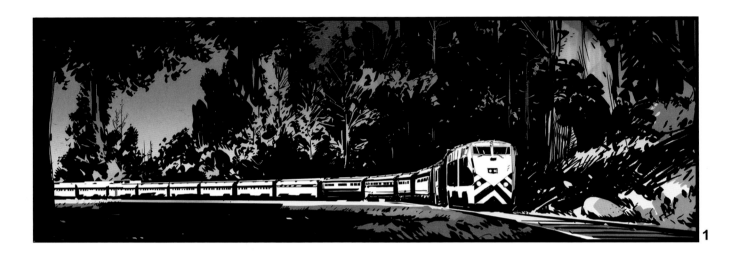

In this case, we are already taking off from a more dynamic approach by emphasizing a deeper sense of space through the use of perspective, meaning the train is now "coming at us."

But, then again, even this approach can have many variations within it.

1 - This first frame shows a train mostly still parallel to the camera lens, almost like in the previous frame 1 on page 076. The first difference, though, is that here the engine wagon is already heading for the camera. Also, the backdrop, instead of a simple and peaceful blue sky, consists of an uphill and dark forest.

2 - The second frame looks even more "menacing," as it is already much closer to us, so close and overpowering that "it doesn't even fit in the frame." Nevertheless, by using a long lens (page 028), we still imply a sense of distance that eases the stress of our point of view.

3 - This last frame is the most dramatic of all six, as we are just inches away from the speeding train now. Using a wide-angle lens adds a level of distortion to the image that increases the drama of it, making the contrast in size between the wheels closest to the camera and the ones barely a few yards away from them, appear huge. The camera has been located very low and with a tilt, a view that feels unnatural to us, given the fact it is making the ground plane feel unstable and that it is seen from an "elevation that makes the train feel gigantic.

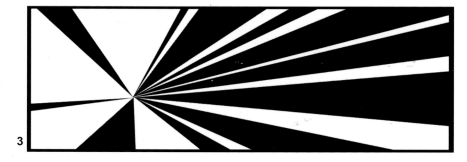

"COWBOYS"
Part 1: Keeping the camera on the same spot

Let's take a look at the elements in the following image.

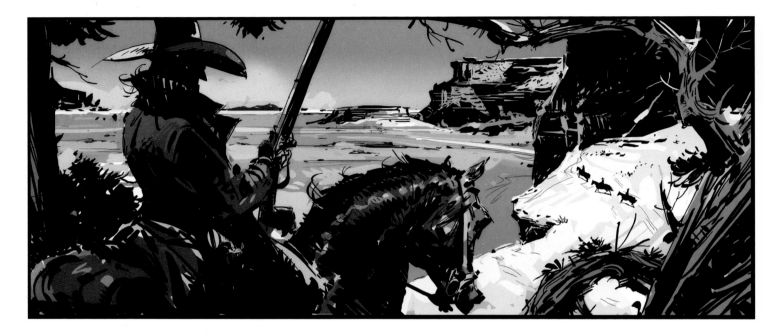

A *cowboy* is the dominant element in the scene by:
- being more elevated in the frame than the other characters
- having his head above the horizon line,
- watching others while the others cannot see him,
- being armed.

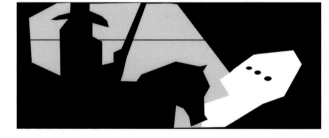

Dry vegetation is in the foreground, framing the scene and somehow concealing the main character from others' view.

Three characters on horseback are in the distance riding away from camera.

An open and spectacular southwestern *landscape* is a backdrop for the action.

As we did before, let's see the many different things we can tell an audience with these same elements and from the same camera position depending on how we frame them, which ones we focus on, which ones we leave out, and what we highlight.

FRAME 1 Whether we are following a previous action, or this is the first shot in our story, we can establish the proper atmosphere and tone of the sequence through the landscape in which the action will take place. Sometimes we can choose to deliberately establish a "misleading" tone that will suddenly have to change to get to the next—and completely different in mood—point of the story. We would in this case be playing the "calm that precedes the storm" effect, so that the change feels more dramatic (see 'use of contrast' on page 075).

FRAME 2 The close-up of the main character's expression tells us what he is thinking, what he is feeling, preparing us for what is to come.

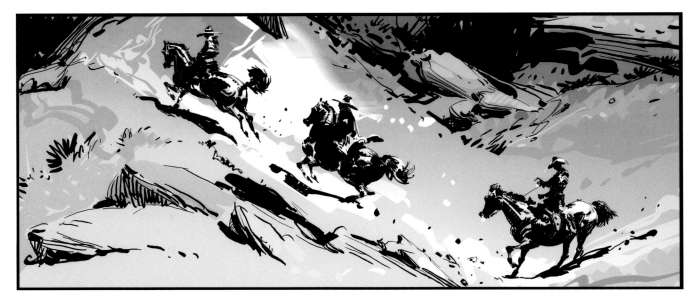

FRAME 3 A closer view of the three *unsuspecting riders* in the distance. The relatively small size of each of them compared to the frame, and the imposing size of the watching cowboy (in the scene before) in its frame, make these three characters appear weaker, almost like sitting ducks about to get attacked any time.

FRAME 4 The detail of the observing character's *gun* tells us in a single image what his true thoughts and intentions are.

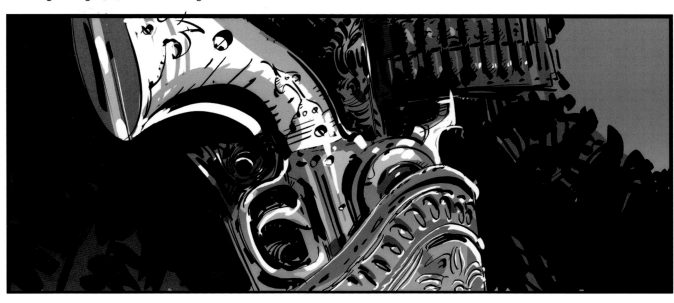

These are all different messages gathered from the same scene and viewed from the exact same spot.

We were talking about the calm before the storm. How about expressing this visually as opposed to with words?

Let's say we want to step up the action in the scene, the character just decided it's time
to bring up the gun and point it at the three horsemen.

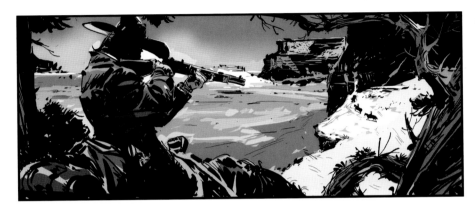

FRAME 5 If we do that while keeping the camera exactly at the same spot, no major contrast will happen, so the increase in *the intensity of the scene will be fairly low.*

FRAME 6 But if we do it while moving the camera closer to the imaginary line between the foreground cowboy and his three targets (page 089), then we will be closer to the shooter's point of view. Therefore we are now in a new visual and emotional place.

So now the mood suddenly became unsettling. But at least we still kept the camera behind the character, as it was positioned since the beginning of the sequence. Therefore we only changed the intensity up to *mid level.*

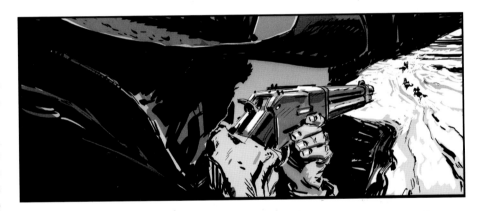

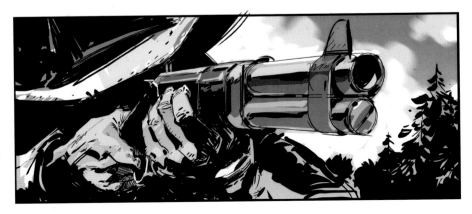

FRAME 7 Let's introduce yet another element by positioning the camera in front of the character now, or should we say in front of the gun? This time we start feeling as if we were in the place of the three horsemen—not a good one to be in. By throwing in a good wide-angle lens, we are going to make the shot even more disturbing.

"THE BIKERS"
Part 1: "Mystery House"

Let's take the following elements:
- a *couple* who just got off a motorcycle
- the *bike* itself
- a *path* that leads to a house on a hill
- the *house*, highlighting a single window in the attic

Now let's compose these same elements differently, mostly by just relocating our camera and therefore getting a new perspective or point of view of the action. (Although the point of this example is to show how different camera positions on the same elements say different things, we will also see that frames 2 through 7 create a sequence continuity within a story.)

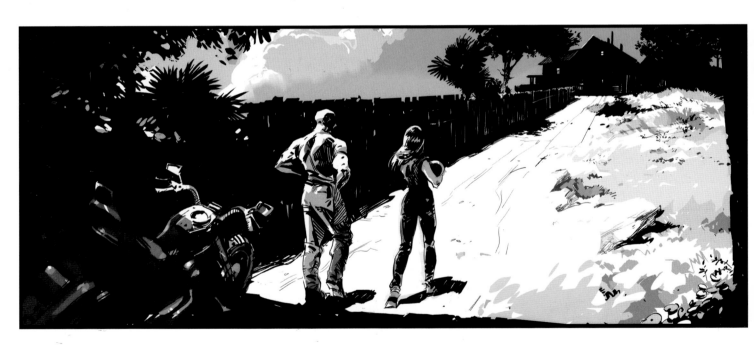

FRAME 1 In this first frame, we see how they just got to their destination and parked their motorcycle. The camera is behind them so we can only get their body language from the back and at a distance, letting us focus essentially on the general development of the action

The general dynamics of the shot is that of a diagonal, the one created by the two main focal points—on one side, the characters and their bike, and on the other, the house on the hill—the diagonal line clearly emphasized by the wall at the side of the path. This diagonal gives the image a feeling of

instability, delivering the message that not everything is as quiet and settled as we would like it to be.

The direction of the sun, our light source in this case, is backlighting the elements that, especially in the case of the house, help highlight an atmosphere of mystery and discomfort.

The cast shadow on the floor (bottom of the image), from the foreground left trees, prevents our eyes from wandering out of the scene and away from the action toward what would, otherwise, be an open bottom of the frame.

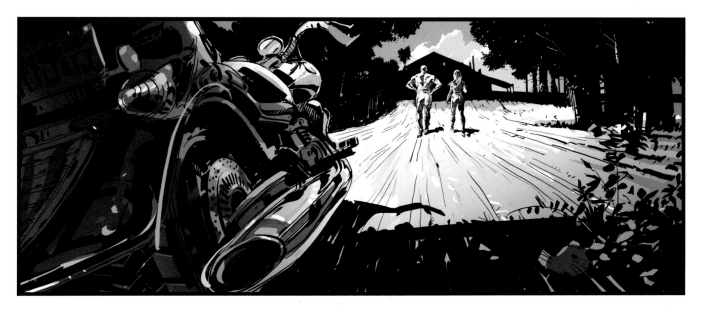

FRAME 2 If in the previous frame the characters still kept a "safe distance" from the house, now they have been visually engulfed, framed and surrounded by it, so that the building has the power now, not them. The election to use a wider lens adds to the distortion of the image and to the drama of it. Also, by lowering the camera, our perception of the moment is that we have been diminished or overwhelmed by all elements in the frame.

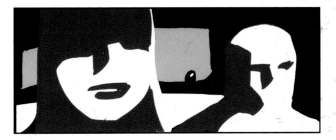

FRAME 3 Now we are completely with the characters, their acting, their reactions, and the apparent calm nature of their conversation that precedes the potential storm to come as they get closer to the house. The bike is still in the background, serving as a geographical anchor or point of reference.

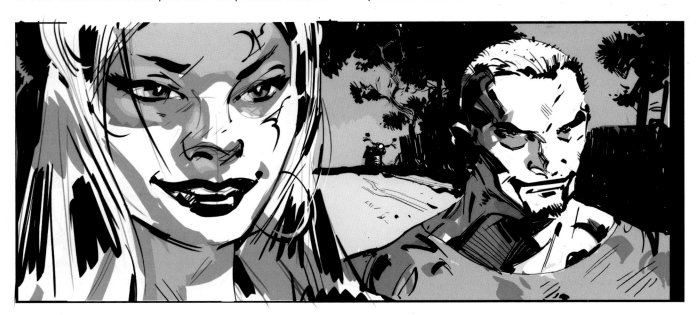

FRAME 4 Things reach maximum intensity as the distance between the characters and the building is minimum now. At this point it feels like the situation has hit the point of no return. The house is now more overwhelming than ever as "it is so big it doesn't even fit in the frame." At the same time, the camera is on the floor looking up, emphasizing the imposing nature of the image.

All of a sudden the characters look up to the window, and so do we as the audience. The window seems to be lit, and it can either be because of a light inside the attic or because of some reflected light on the glass pane from the outside. Whatever it is, all the elements are now pointing at it, and we will need that...

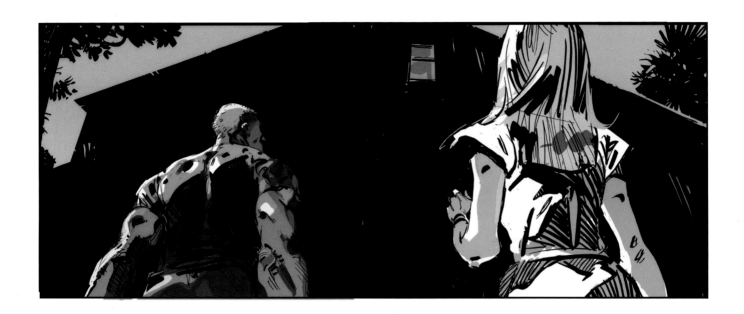

...since we are now getting ready for a *TRANSITION*.

FRAME 5 Going from one side of the window to the other in two consecutive shots and keeping at least some of the same characters in the scene, we understand the connection between the two setups without getting lost in the geography of the full location. Here we are also revealing new information in a way that the audience is now aware of the potential danger the two bikers are subject to, danger they are completely unaware of. This way the atmosphere becomes immediately more intense.

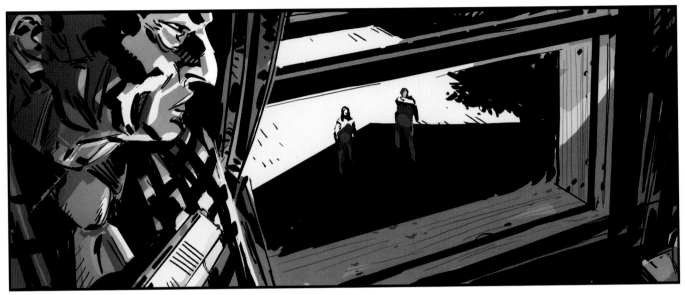

Also, the line that goes from the eyes of the mobster in the attic toward the eyes of the couple outside (thumbnail left) is clearly going downward, establishing a visual dominance and control of the man over the couple. The gun he is holding close to his chest is also pointing in their direction, adding visual pressure on them.

4

5

Notice that when putting shots 4 and 5 together in continuity, and in order to avoid mistaking any of the characters for another during the cut *as would happen if they occupied the same space on the same side on the screen*, we make sure the main weight of the scene changes then from right to left (pages 025 "The Line," 057, 089, 114).

Just as we always compose all the elements within each still frame with a general flow, or sense of tension (see all previous thumbnails in the book), because we deal with sequential art, we will apply the same principle to the actual screen as the common element between all still frames that is. This is so that each main element or focus of attention in one shot will be coordinated with the next in a way that, when put together *in continuity*, they all offer a sense of flow, motion, and higher or lower organization and tension as well that will help enhance the narration.

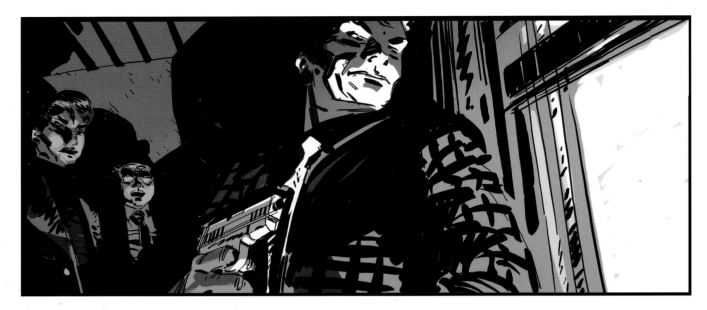

FRAME 6 The mobster closest to the window is still dominant after the cut, as we now see him in an upshot. The square pattern of his jacket makes clear whom he is in relationship with the previous shot, making it a fast read for the audience. The characters in the scene are lit by what seems to be reflected light from the ground outside or some mirror-like surface, taken to a graphic and visual extreme, which enhances the disturbing look of the fellows. Due to the fact that the three heads create a virtual triangle, the scene becomes more uneven and interesting as opposed to if they were composed in continuity following a flat line (see train examples on pages 076–079).

FRAME 7 Now we close in on who seems to be the brains of the operation as his calm, "in control" look reflects. It's a "cut in," meaning we keep the camera pointing *exactly* in the same direction and from the same position, while all we do is move it forward.

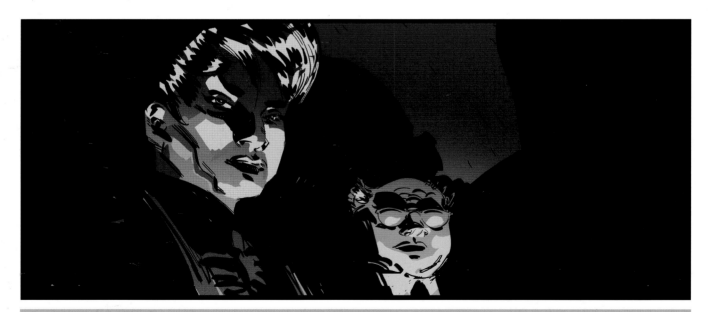

This way we went very smoothly from the bike outside, a good distance from the house, to the boss of a dodgy operation inside the house's attic, by *transitioning naturally* and not creating distracting moves that would take us away from the narration of the story.

THE LINE

We have talked before about the need to keep things clear from a geographical point of view. Our audience is here to follow a story and the emotional rollercoaster we deliver through its narration. They shouldn't have to, on top of that, start worrying about stuff that might get in their way when it comes to following the story properly, such as "where is what" in the shot.

Imagine you are watching a football match on television. You know the two teams well, their players, the colors they are wearing, the field they are defending, and the goal where they are trying to score. All this basic knowledge would be completely ruined the moment the director tried to shoot the event from the opposite side of the field simultaneously. We just wouldn't be able to follow who is who, who is going where, or who is doing what if we had to focus so much on it that a big headache would be guaranteed at the end of the show.

Unless we want to confuse the audience on purpose, because the moment requires so (for example, if we need to put ourselves in the shoes of someone who has just been kidnapped and taken somewhere unknown to him), we need to make sure that the geography of the location we are in and the position of the characters within it is clear enough so that any action they may take there, or from there, is easily understood by the audience.

For this purpose, we will need to follow one very simple rule: to stay on "the same side of the line," which connects and runs across the two main elements in the scene while we witness the action unfold. By doing so, we will have one very strong point of reference; the background behind the characters will always be the same, and all actions will be anchored to that reference.

Let's see the previous examples of "Cowboys" and "The Bikers" from this point of view now.

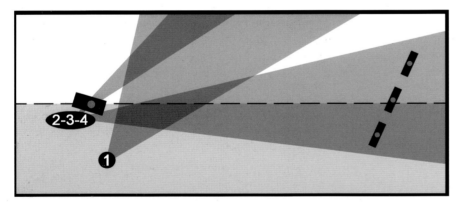

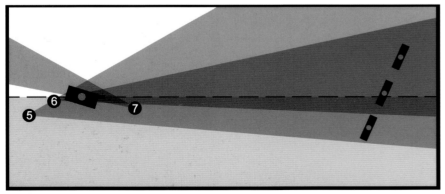

"The Cowboys"

Frames 1 to 7 of are represented and numbered in these diagrams. In them we can see how we established "the line" between the two main elements in the scene's action, which are the cowboy with the rifle in the foreground and the three horsemen in the distance.

Once this basic element has been set, we can then clearly see how the camera has been placed according to the principle explained. Also observe how, as a result, we can always place the gunman consistently favoring screen left as opposed to the three horsemen and the mountains that tend to favor (even if just slightly) screen right.

Let's now see the same applied to "The Bikers" sequence.

"The Bikers"

This case has an additional feature since we *transition* from one action to another (exterior to interior) within the same sequence, therefore, we play with two different camera lines, which we will see are connected anyway.

PART 1 The axis here runs between the two bikers and the house. The camera is on the right side of it from the character's point of view, so the wall to their left offers a consistent backdrop for the sequence. In shots 2 and 4 we go right *on* the line, a neutral position that still offers a good understanding of the geographical elements of the location, and *does not* cross the line. (Note: If we ever *needed* to cross, we could get away with it by doing it in one single camera move, which would start and end on the different sides of the line with *one* single motion of the camera, so that we could still keep track of the general situation.

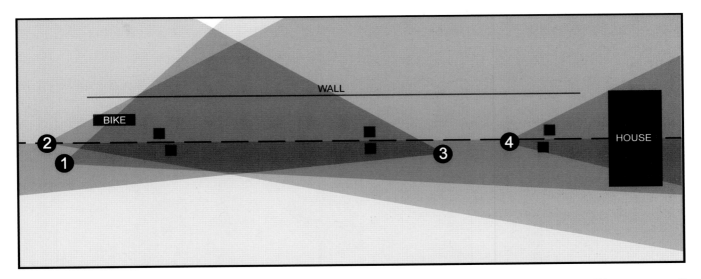

PART 2 We are in the attic now. For the first shot in this new part of the location, shot 5, the camera is obviously still on the same side of the original line, in an area that is going to be our "transition zone," right between the line from the first part of the sequence and the new line that we will have as a result of connecting the two new main elements of the second part of the scene, the "crook in the square pattern jacket" and "the two mobsters at the end of the room."

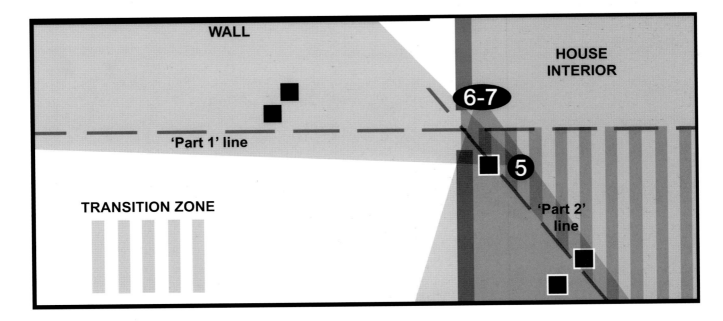

CHAPTER 5

THE GRAPHIC NOVEL

Before stepping into this new and distinctive field, know that everything that has been said so far in this book can be applied to this medium as well.

What comes next is particular to the "graphic novel," or at least to a specific way to work. (Let's always leave a door open to exploration or to enhancement of what one takes for granted.) But we should always count on what other fields such as film, theatrical arts, shadow puppets, and the like that can enrich our style of work.

PART 1

THE CHARACTERS

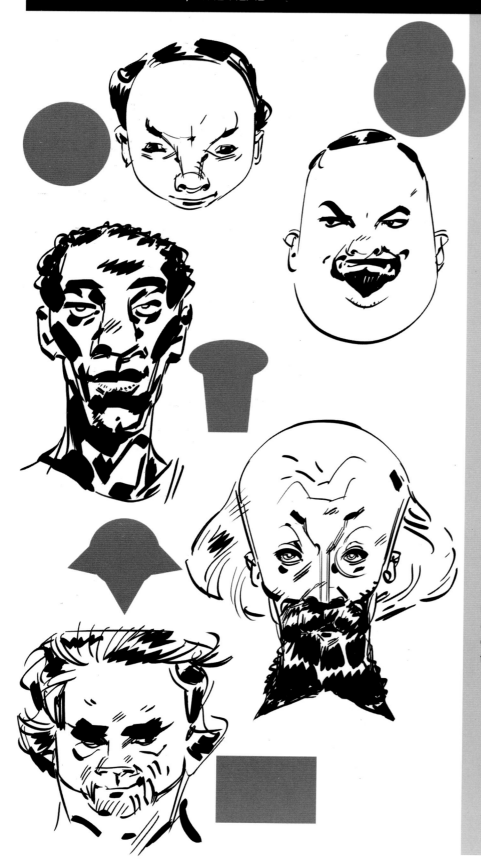

Comic book and graphic novel characters don't seem to restyle their hair, shower, or even change their clothes all too often, truth be said. And there is a good reason for this.

We mentioned before that we are moving in the world of creating illusions, of making people believe things that are not real or, to be more accurate, to create realities that are only in our brains. Are realities ever anything else but that anyway?

The moment we deal with live action characters, they are instantly recognizable from each other, but when they are drawn on paper, we have to supply them with those extra personal touches that will definitely bring them up to the level of what will impact us.

It is a bit like theater or opera. Their audiences have the immediacy of live actors in front of them, though they are usually at a distance, making it difficult for us to get a real grasp of every nuance and gesture in their acting, and that's why such acting in these cases is more emphasized than the one that takes place in front of a film camera. In movies we can get every little reflection of light in the corner of an eye and deliver it to the audience thanks to the amazing work of the directors of photography and their team.

So when it comes to creating characters for a graphic novel, we will have to make clear statements in this direction. Of the many differences we can create among our cast, the first one we focus on is the silhouette.

Making him or her recognizable in any sort of circumstances, including any type of framing and lighting, will be essential. By doing so, we will have a clear read of who is who at any time, allowing us to progress through the story without having to get stuck in a frame or to go back to double-check this or that.

This will include both the front and profile of the character design as well as his or her costume whenever possible. Obviously the moment we count on color we will have an additional tool to work with toward this end.

In these examples we have an indication of how we can simplify shapes to a point that will make it easier for us to work on this issue.

After this, the next step will be to work within this shape, adding up to their personality. Here we can play with the expression of the eyes, the position of them in the face (closer together, more separate, squinting, wide open), the style and color of the hair, the amount of it, and so on.

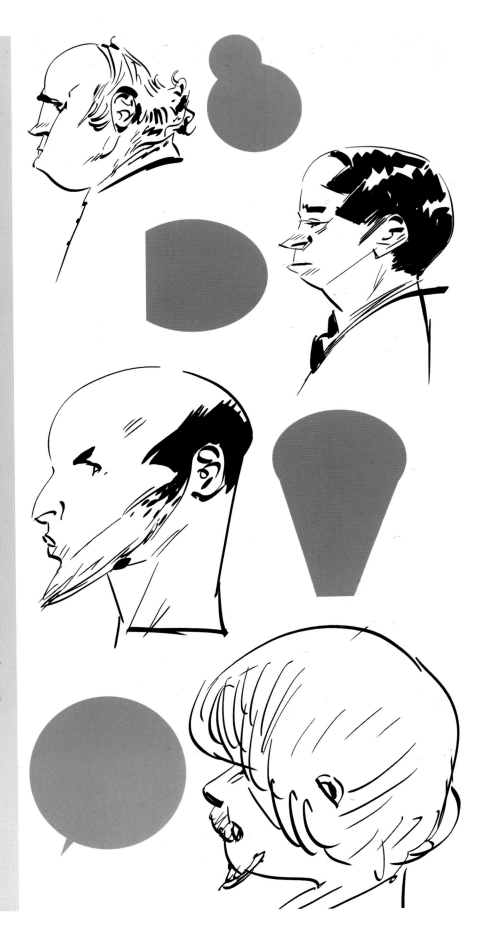

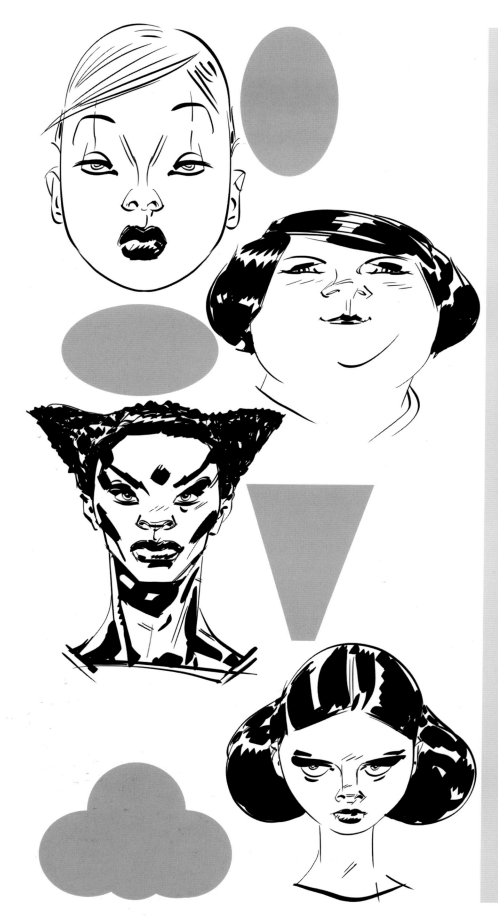

Other elements to take into account will be the height at which all these elements are positioned within the face, the proportion of the distances between the eyes and the eyebrows, between the spaces left above and below the eye line, between the bottom of the nose and the lips, between the lips and the chin, how thick the lips are, how wide, if the upper lip is more prominent than the bottom one, or is it the other way around?

In addition, how round or how angular in general the shapes are, are they only one or the other? Or are they a combination of both? Also, the more symmetrical the front of a face is, the more appealing somehow it will be, as we are genetically attracted to balance and perfection.

All these can be applied to what is happening around the head shape and within its space, but obviously we will also count on additional shapes like the hairstyle, including any possible ornaments as well as its color.

Again, no matter how different the shapes may be, we will always take care of making them feel connected to the same world. Like in the storyboard process when making a film, we should never do anything that, once the "world" for the story is created (and to that, everything contributes: pacing, lighting, framing, character design, acting, and so forth), would pull us out of it by being completely alien to what we have established.

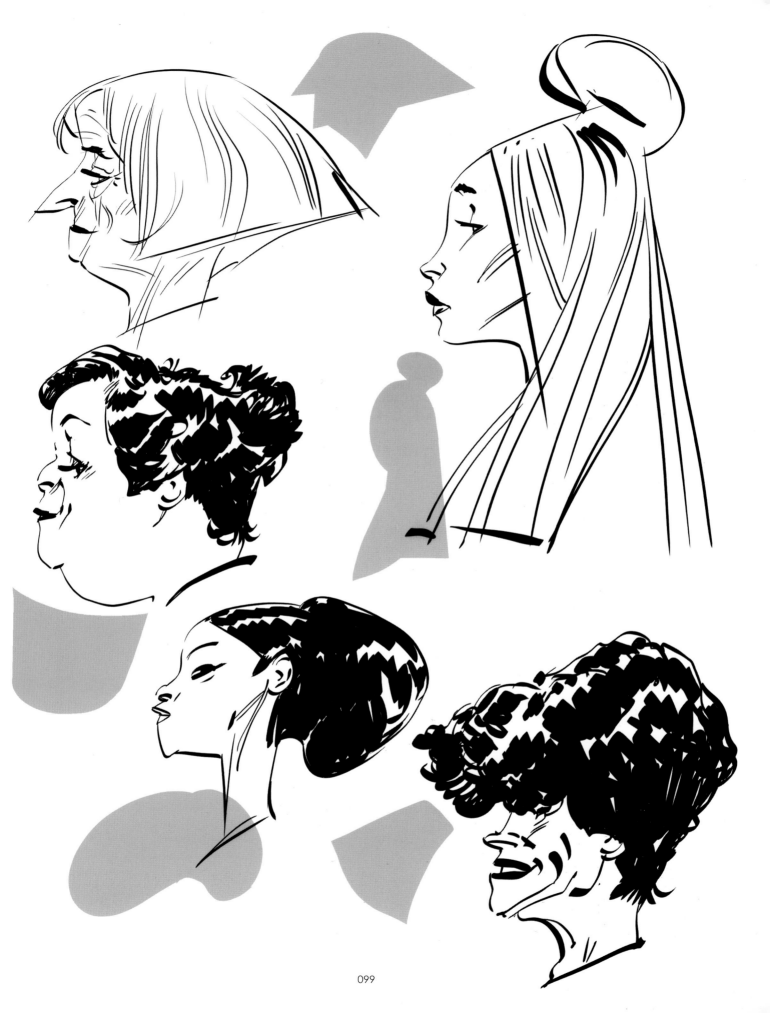

The same principles would apply to a character portrait in full body. As a head with a new accessory can dramatically change its silhouette to something very different, also characters with similar body structure can dramatically change their visual impact when wearing completely different outfits, which, as mentioned before, they are most likely to wear consistently throughout most of the story.

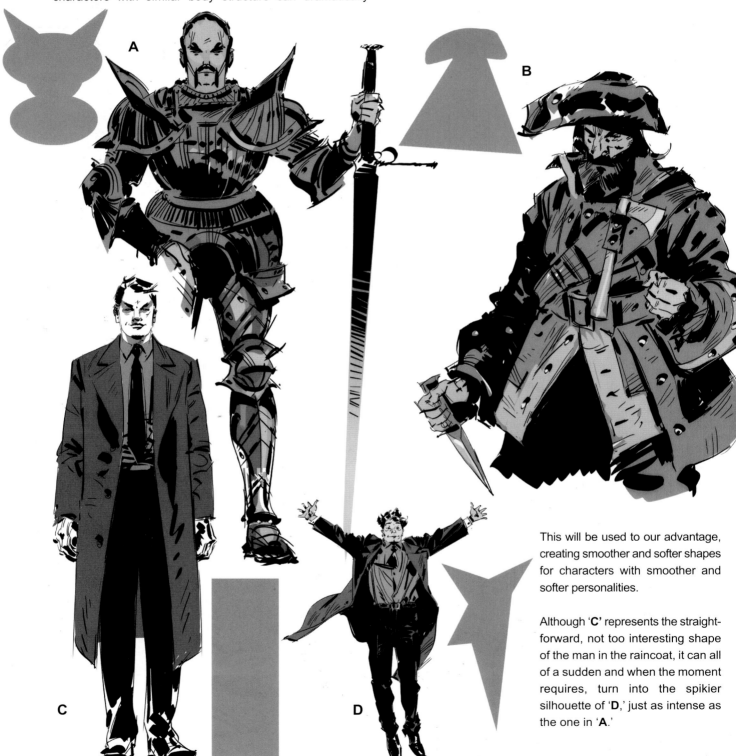

This will be used to our advantage, creating smoother and softer shapes for characters with smoother and softer personalities.

Although 'C' represents the straight-forward, not too interesting shape of the man in the raincoat, it can all of a sudden and when the moment requires, turn into the spikier silhouette of 'D,' just as intense as the one in 'A.'

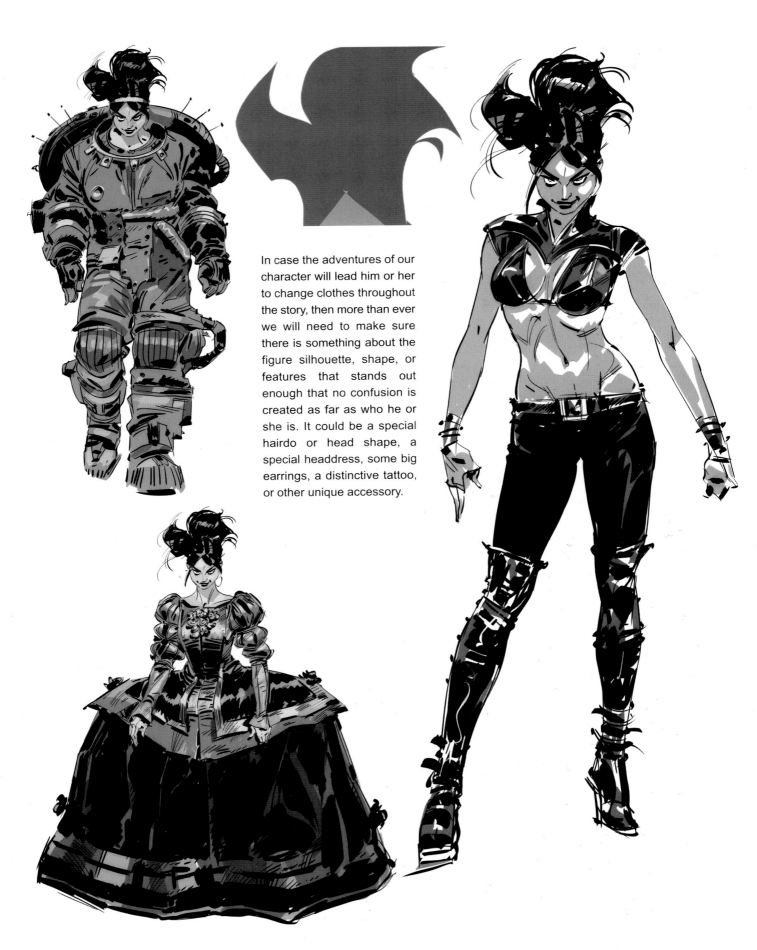

In case the adventures of our character will lead him or her to change clothes throughout the story, then more than ever we will need to make sure there is something about the figure silhouette, shape, or features that stands out enough that no confusion is created as far as who he or she is. It could be a special hairdo or head shape, a special headdress, some big earrings, a distinctive tattoo, or other unique accessory.

Ultimately, stories are about human feelings and moods, usually expressed by humans, although sometimes also by animals or anything else an artist can project human emotions on. Therefore, the expressiveness of the characters in our stories will be essential to transmitting what they are about at every moment during the development of the narration.

It is a shape language that can go from the most relaxed pose to the most outrageous one, including everything from the character's face to the general sense of dynamics of his or her body pose, as well as every detail and subtlety within this general contour. As a general rule, angular shapes will appear more tense, and softer shapes will feel nicer and more relaxed.

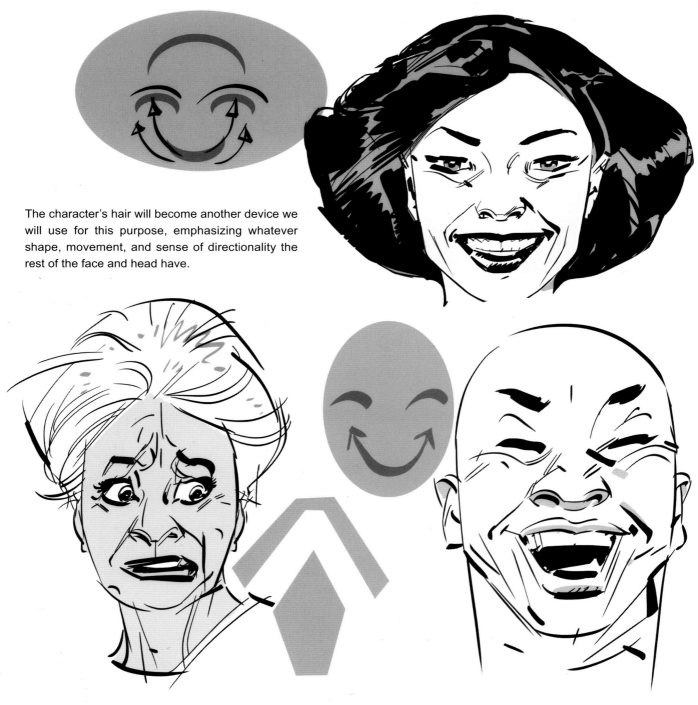

The character's hair will become another device we will use for this purpose, emphasizing whatever shape, movement, and sense of directionality the rest of the face and head have.

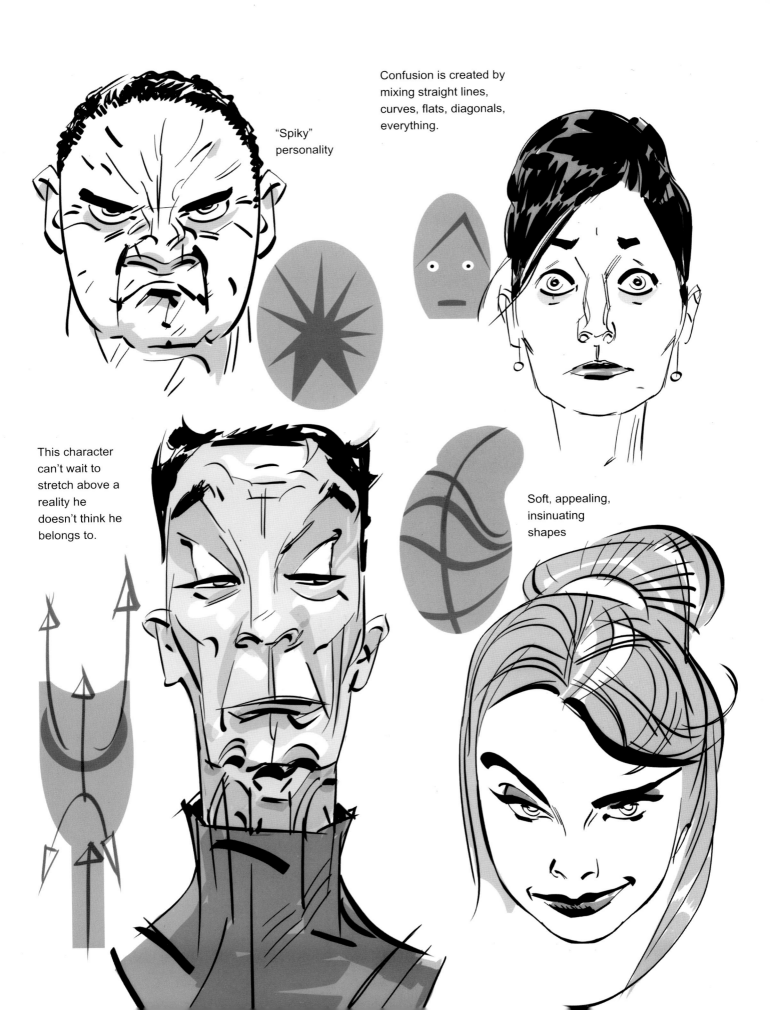

"Spiky" personality

Confusion is created by mixing straight lines, curves, flats, diagonals, everything.

This character can't wait to stretch above a reality he doesn't think he belongs to.

Soft, appealing, insinuating shapes

Again, in order to emphasize the mood of the moment, we will use the graphic options a whole body is offering to us. We will try to deliver interesting poses with a level of complexity in them to make the delivery of the message interesting, but the readability will still have to be there.

We will also always be aware that the character pose will have to work *every time* with the elements around, such as location, camera angle, and lighting, becoming part of a well-balanced and meaningful composition.

In moments of expansive action, the core lines of the drawing will be diagonals. Off-balance shapes against smaller counteracting ones to keep a sense of precarious but believable balance of the figure.

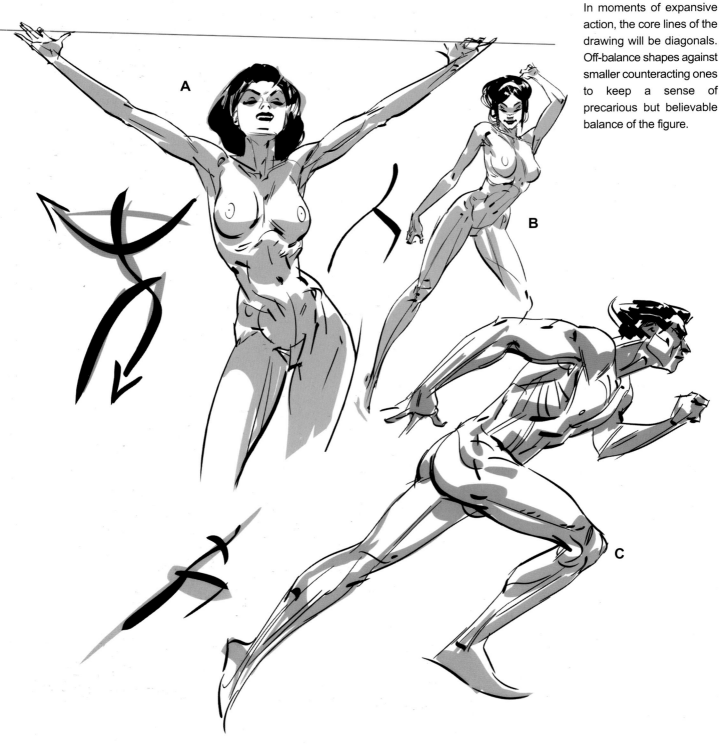

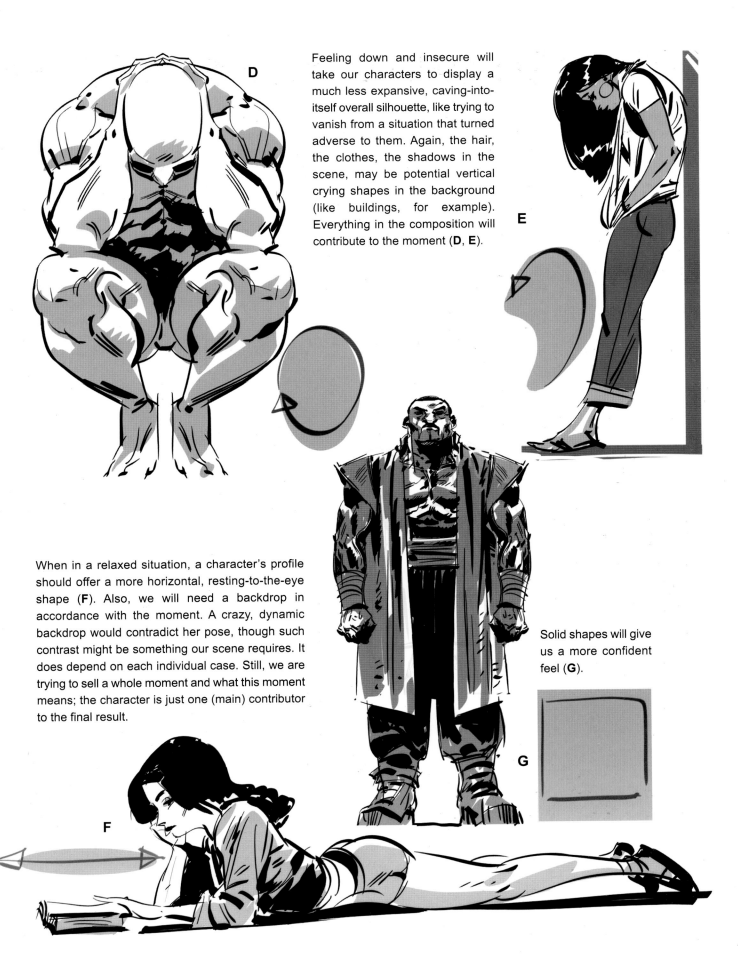

D

Feeling down and insecure will take our characters to display a much less expansive, caving-into-itself overall silhouette, like trying to vanish from a situation that turned adverse to them. Again, the hair, the clothes, the shadows in the scene, may be potential vertical crying shapes in the background (like buildings, for example). Everything in the composition will contribute to the moment (**D**, **E**).

E

When in a relaxed situation, a character's profile should offer a more horizontal, resting-to-the-eye shape (**F**). Also, we will need a backdrop in accordance with the moment. A crazy, dynamic backdrop would contradict her pose, though such contrast might be something our scene requires. It does depend on each individual case. Still, we are trying to sell a whole moment and what this moment means; the character is just one (main) contributor to the final result.

Solid shapes will give us a more confident feel (**G**).

G

F

PART 2

THE PANEL
AND THE PAGE

Displaying the Story

One of the main features that makes a film and the graphic novel different from each other is the format.

In a *movie* theater, we have one screen onto which all images are projected, one frame at a time, creating the illusion of movement. Also, while shooting the film, the camera has the ability to pan up and down, left and right, diagonally, truck in and out, zoom in and out, and do it all with a continuity as smooth as we plan it to be.

A classic *graphic novel* is printed on paper, showing a continuity of images that relies on still panels to be its physical support. Through them we will have to create the illusion of a movement that does not really exist. Our devices for this medium will be different than the ones of film, because now we will have panel size, panel shape (square, rectangular, vertical, horizontal, circular, triangular, irregular shape, whole page), panels within panels, the use of balloons and onomatopoeias, and so forth. Still, the basic principals of framing, lighting, and sense of rhythm will remain the same.

Let's see some examples of the devices we just talked about, and how they work.

Depending on the narrative needs of the moment, we will be able to frame and display the same basic setup in many different ways and formats. Here are a few examples.

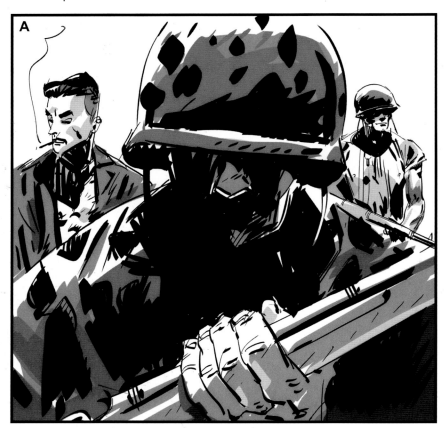

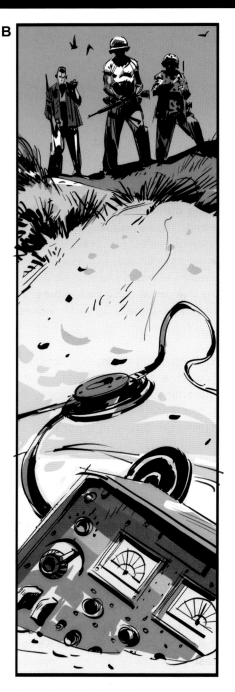

'A' is using a perfectly square format to present us the three characters. In this space we can include the essentials to see that they are soldiers and, although they belong to the same army, we already see the distinctive features of each of them despite the fairly sketchy execution of the drawing. Two wear a helmet: one with camouflage (like his shirt), one without (a white T-shirt covers his torso). The third soldier offers a clear view of the features of his head and smokes a cigarette. Cropping everything else out helps us focus on the levels of drama and tension of the trio.

The vertical format in '**B**' helps us display the descending path they have to follow to reach the abandoned radio they are searching for, again maximizing the space within the format by having only the three characters, the space between them and their objective, and finally the transmitter.

As their mission progresses, they walk along the endless trails of a Pacific island. The panoramic format of '**C**,' helps us feel the size of the landscape while perfectly accommodating one of the men's rifles to establish the drama, the time period, and the will of the three servicemen to push the mission forward.

'**D**' is an action displayed in continuity through a series of panels. As the character quickly moves downhill, the panels open more and more in the direction he is running to and ends up revealing his final pose as well as the pose of his two comrades. The diagonal line created by the bottom of the panels adds to the sense of action and drama of the scene. Finally, the last panel becomes suddenly wider than the others just in time for the big explosion to happen.

Sometimes we might have an odd shape left in the layout of a full page that we want to maintain, that we can easily accommodate to a specific purpose or meaning. In this case we use the potentially uncomfortable pointy shape of the triangle top in '**E**' to fill in with a simple, repetitive, and not too relevant pattern of the palm tree leaves.

The possibilities for shapes are as unlimited as imagination and purpose.

Circles (**F**), ovals, squares, rectangles, triangles, inverted pyramids, and the like, as far as they serve our narrative purpose *and don't become confusing agents in the overall layout design of our page*, will just make our storytelling richer and more graphic whenever needed.

Finally, let's review subjects we have already seen in this book, such as contrast and climax. The same principles that would apply to a movie or the execution of its storyboard would also apply here. The overuse of rather spectacular and dynamic visual devices consistently throughout a graphic novel would leave us with nowhere to go the moment we tried to create a very special or intense moment, or tried to build toward the end of the story. Again, let's create rhythms and then let's break them for dramatic effects. Let's apply things only where they belong and in the right amount.

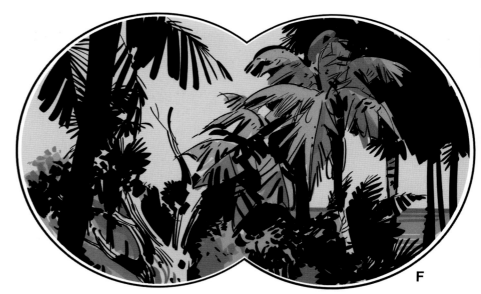

F

G

These different panel shapes we use to frame and express our story moments are obviously only parts of a bigger storytelling unit that is the page.

Once we have an idea of what shape we need our panels to be in order to make our visual statements at every point of the story, we will need to make sure that the moment we put them together, they all configure *a solid and meaningful page layout.*

We will need to know how repetitive or how unpredictable the rhythm has to be once in continuity. Is the reading going to be more linear or more irregular and disrupted? Are the frames going to be more straightforward and steady in their shape, or are they going o include more diagonals and therefore a bigger sense of unbalance?

Whatever the answers to these questions are, one thing will be a main priority, the *clear readability of the page.* The audience is there to follow a story, not to try to figure out what a page layout means or in what order the panels are. This simply would, as we have mentioned before, pull the reader out of the story for good.

Choreographing the page

As we saw in the example of panel sequence '**D**' (page 109) the moment we have a series of panels depicting a repeated element throughout, we will try to make sure, for fast readability purposes as well as the creation of a smooth and "cinematic" move, that *the main point of such element* in every frame (in '**H**', the center of her eyes, in '**D**,' the whole head of the running soldier) *is located along a main line*. Whether that line is straight or curved, it should follow a *predetermined and harmonious path* to ensure the reader doesn't lose the flow of the moment.

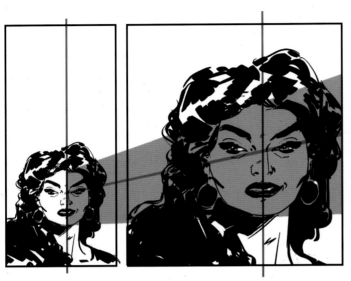

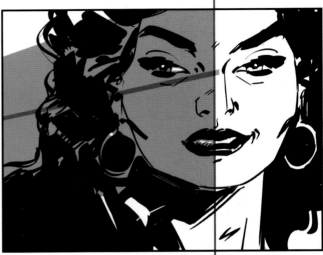

H

This is a principle that applies not only to individual elements along a number of panels, but also to the *layout of entire pages* and sequences of action. '**I**' and '**J**' are an example of it, in which *every panel on the page is in structural harmony* with the others by having all their perspective lines converge in one single vanishing point.

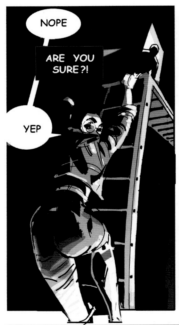

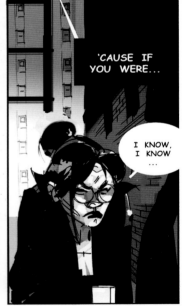

I

J

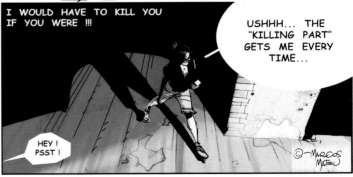

K

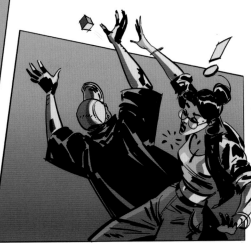

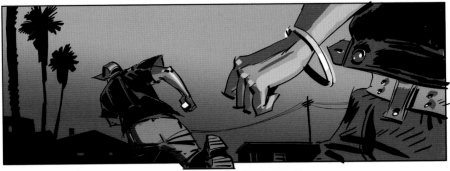

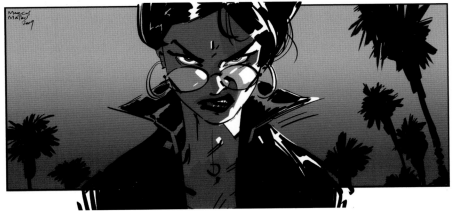

L

'K' is another example of choreographing a page around the movement of the main subjects.

Let's use a little box as our characters' "object of desire." It's being thrown up in the air during the struggle, and eventually the guy wearing the baseball cap pushes its legitimate owner (the girl) out of his way, grabs the box tight, and starts running away from her. She just couldn't be madder. We can tell the next thing she is going to do is chase the guy until she gets back what rightly belongs to her.

The devices we used in this case in order to deliver the message properly are:

• **Panel 1** This is a tilted upshot. This way it is easier for us to feel we are part of the struggle and losing balance in the action. The background helps us emphasize the sense of perspective, but without too much detail (purely silhouettes) so that it doesn't distract us from the action. The same purpose is achieved with the irregular shape of the panel.

• **Panel 2** She is pushed away from the box. The two bodies are basically two opposing diagonal lines, adding to the intensity of the drama.

• **Panel 3** After two constrained panels (1 and 2) in which we convey a sense of fast-paced action, we now expand the surface horizontally, giving the bad guy space to run. Until now, as we see in 'L,' we have kept a coordinated and smooth path for the eyes to move throughout the page, a curve created by linking the points where the box is located at in every panel. Also, her arm in panel 3 helps direct the eye in the established direction (to the left).

• **Panel 4** Things are getting serious now, and we are clearly done with the previous action, ready to get into the next one, but not before having the appropriate tense pause, depicted in this case in this "neutral camera shot" straight on her face that lets us fully appreciate her expression. After this we will try to keep the "screen direction" left for the rest of the chase.

Fragmenting the Scene

In '**M**,' right below these lines, a young and adventurous female character has just been left alone in a creepy palm reader's office during the course of an undercover investigation. She looks toward the staircase he just used to momentarily exit the room (only light source around) as she is trying to gather more information about the place. She starts looking to her right, into the dark (as the "camera" is used as her POV). She perceives somebody else's presence next to her, but still can't see anything. As her eyesight gets more and more used to the dim lighting, all she can distinguish are abstract shapes. At this point her heart beats faster and faster (as the panels get narrower and narrower, accelerating the rhythm) until another light is finally switched on, revealing what she feared the most.

'**N**' on page 115 is another example of how to use the layout of the page and its fragmentation in panels in order to create a flow that will make the audience move through the moment easily and with a purpose while following the character and his thoughts. Wandering around the same "stage" is a particularly effective and theatrical approach; here we don't need to change from one camera position to the next and so on. There is no particular intense point or alteration of the detective's emotions during this scene at first. He is just quietly putting his thoughts together until he happens to discover the mysterious object on the pavement.

And this is the way we will treat this scene visually, with a similar, quiet rhythm of panels at first, with basically the same elements and setup. The moment something special happens, that will contribute to changing the course of his investigation: the setup suddenly changes, the size and format of the panel changes (narrower), the main element in the panel changes (from the man to the glasses), and the overall lighting tone of the panel changes (from the man being dark on light to the reverse glasses light on dark).

M

THE GOOD NEWS WAS I HAD HAD PLENTY OF TIME TO CHECK UP THE APARTMENT...

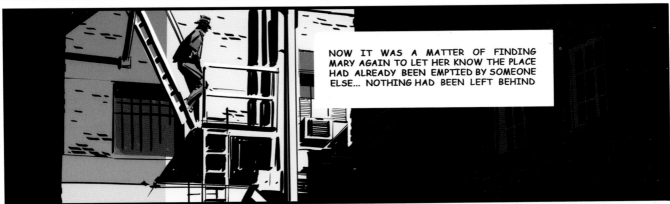

NOW IT WAS A MATTER OF FINDING MARY AGAIN TO LET HER KNOW THE PLACE HAD ALREADY BEEN EMPTIED BY SOMEONE ELSE... NOTHING HAD BEEN LEFT BEHIND

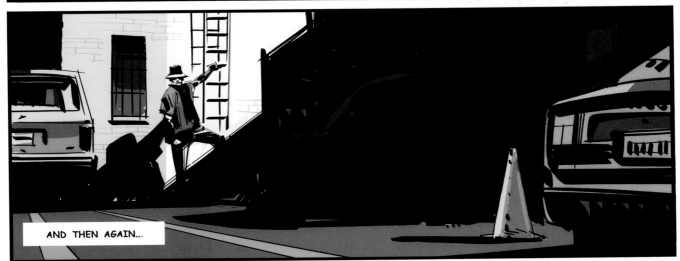

AND THEN AGAIN...

MAYBE I WAS WRONG

The moment we plan the rough layout of a graphic novel page, we have to take into consideration the positioning of balloons and onomatopoeias if we are going to use any. Same as with the artwork, they have to serve a specific purpose within the storytelling context and to clarify and help the action, never being senseless or confusing in any way. Therefore the order and shape in which they will appear will need to be carefully thought out.

In example 'O,' we have a fairly complex situation:

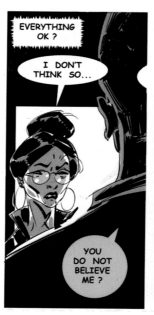

Three people are talking at the same time.

The scenario is, our character has finally gotten into the palm reader's office to investigate, while the secret agents who sent her in are waiting outside in case something goes wrong, keeping contact with her at all times through an earpiece. Both the bad guy and the agents keep talking to her simultaneously while she is trying to answer both. Each party takes it he is the recipient of her words, creating a very confusing situation.

The planning of the order in which the balloons appear is crucial, as is the distinctive shape and color of each balloon, representing each one of the characters.

Case 'P' shows us how to economize and simplify a conversation between the two agents when there is no need to get anymore complicated than that.

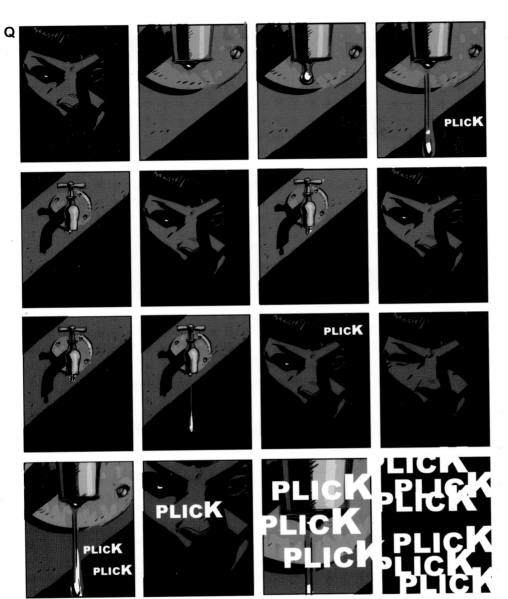

As far as onomatopoeias are concerned, their proper use will help us enrich and complete the visuals on a page, becoming part of them, creating rhythms, pacing and powerful graphic effects that are unique to the medium of graphic novel.

Same as with the balloons, onomatopoeias will need to be laid out and placed in the right places and with the right sizes the moment we sketch out the page, so that they can create the desired effect that will, in a way, be the equivalent of the sound effects movies are so rich in.

As we see in 'Q,' such a device can absolutely take over the visuals at a certain point, creating a level of abstraction in the panel that will have a certain impact on an audience: In their minds, they will substitute the onomatopoeias with the actual sounds they are trying to recreate.

In example 'R,' this device is also used to enhance the perspective of the frame.

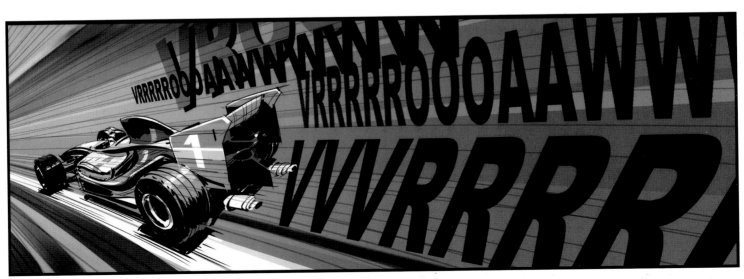

R

LAST THOUGHTS

Although it might sound a bit melodramatic, any form of art is an investigative approach to what life is or means to us, to what we see and how we see it.

What we communicate through our drawings should relate to us at the most intimate level, and therefore be full of sense and meaning. It should respond to our perception of reality and to our need to communicate it for the sake of discussion, to bring something to the table that will eventually spark a response from someone, or even ourselves, once we see our thoughts materialized in front of us. This, given the fact that what we feel as an abstract thought will challenge us again once turned into something specific, material, and tangible (a drawing, storyboard, design, etc.), either because we will need to wrestle it into what we think it should look like, or because it will come out as an improved version of it.

Creating art will force us to make that extra effort to rationalize the things that are the deepest in our minds.

It will be an elaborate process, long and complex. It might take many sketches and tryouts before we are able to put on paper what is running around our brain cells, and to do so in the simplest way possible. (Remember, things can be complex, but should not be complicated, the difference being the former refers to the necessary, the latter, to the disposable or unnecessary).

Let's detach ourselves from our work from time to time to have a better understanding and control of what we are produc . Literally, let's step back and look at it from a distance, let's make sure it reads properly and that the eye goes where it should go at every step. Let's see that the overall rhythm of what's on the paper (both as individual pieces and in continuity) is interesting and appropriate for what our message should be.

Fortunately enough, the more we practice and think about what we want to say, the faster our "visual words" will come out from our brushes.

And this might also turn into an important practical factor because, as most people will agree with, speed at work at all levels is an important commercial requirement in the "visual storytelling" industry, and things will only become fast the moment targets are clearly identified, the moment we know exactly what our story requires. Places will always be reached faster by driving an older, regular car with a good GPS and set of maps—or by not being shy when it comes to asking directions!—than by driving a fast sports car or the newest model, but without knowing where we are going.

Let's set up clear goals, and let's get ready to express them as clearly and simply as possible. Let's rationalize them, let's get to know why we want and need to get there, and then let's start driving.

It's going to be a blast.

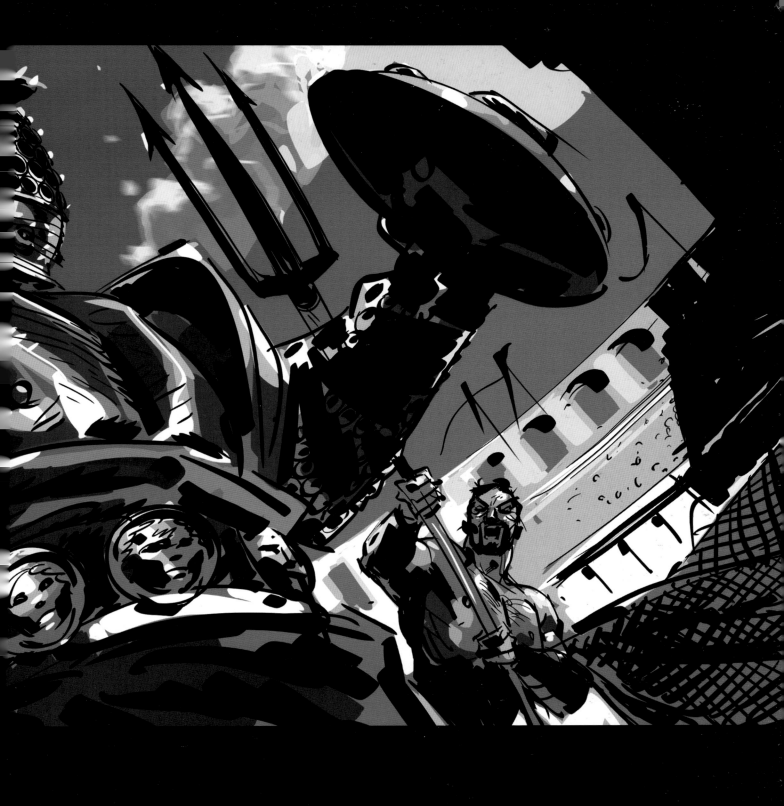

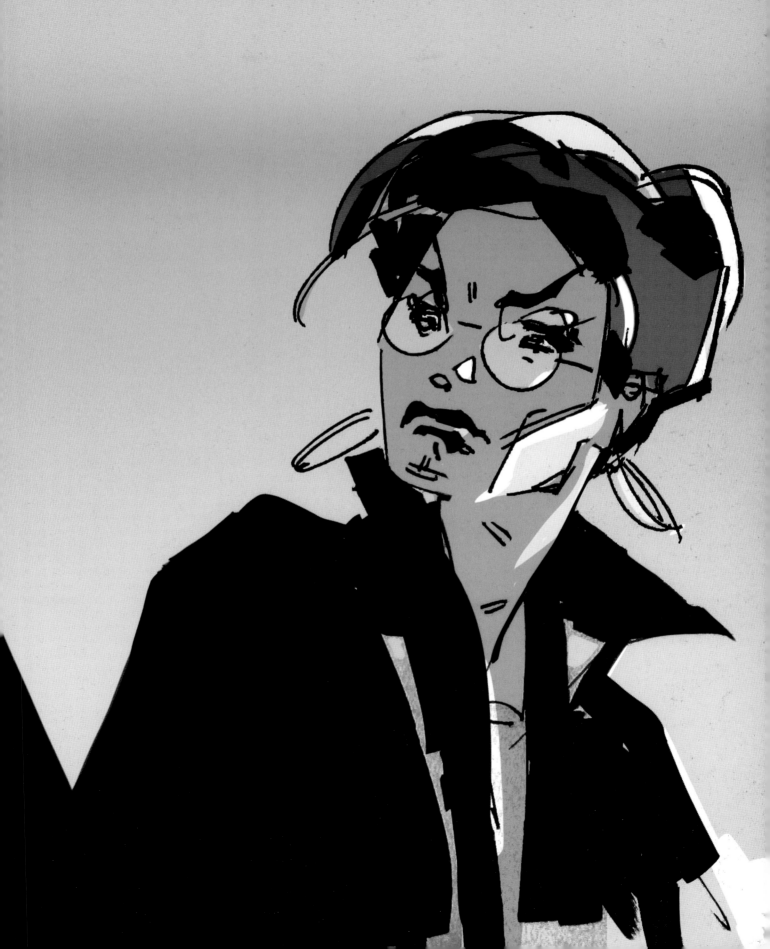

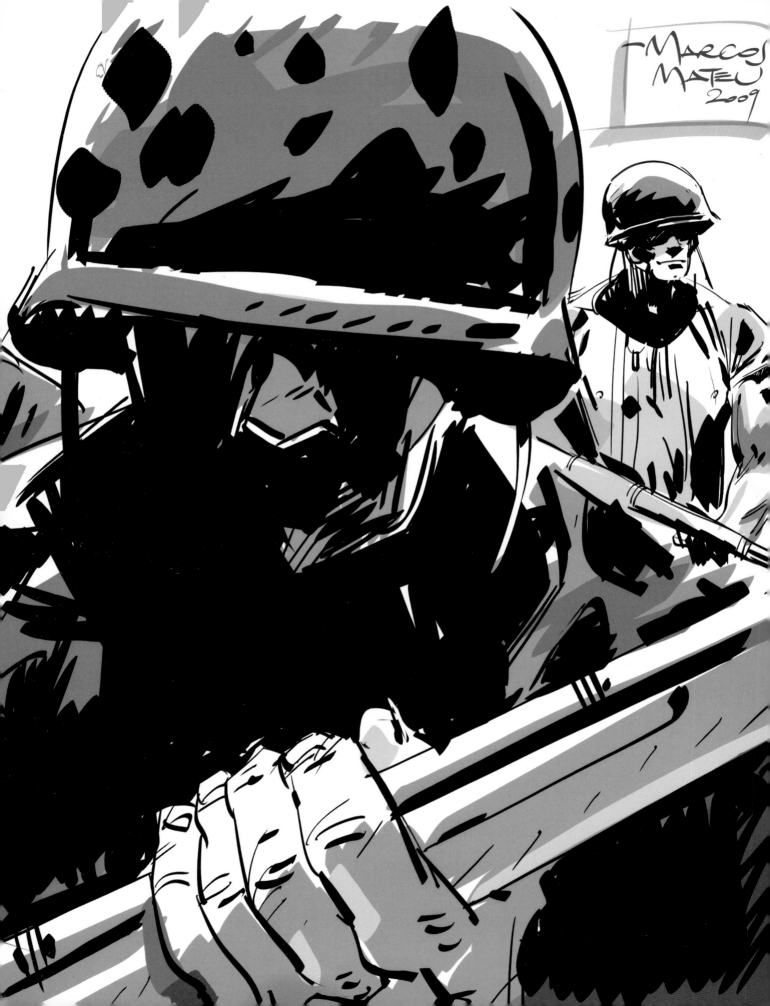

You can visit Marcos Mateu-Mestre at
http://marcosmateu.blogspot.com/
http://marcosmateu.net/
marcos_mateu@yahoo.com

INDEX